THE MASTER GUIDE TO

SLR

AS

...ding manu-
, and more

Ron Eggers *and* Stan Sholik

AMHERST MEDIA, INC. ■ BUFFALO, NY

To Sarah and Luke.
—*Ron Eggers*

To the women in my life for allowing me the time: Linda, Amelia, Lilu, Strawberry, and Cow.
—*Stan Sholik*

Copyright © 2005 by Ron Eggers and Stan Sholik
All rights reserved.

Published by:
Amherst Media, Inc.
P.O. Box 586
Buffalo, N.Y. 14226
Fax: 716-874-4508
www.AmherstMedia.com

Publisher: Craig Alesse
Senior Editor/Production Manager: Michelle Perkins
Assistant Editor: Barbara A. Lynch-Johnt

ISBN: 1-58428-143-X
Library of Congress Card Catalog Number: 2004101345

Printed in Korea.
10 9 8 7 6 5 4 3 2 1

Notice of Disclaimer: The information contained in this book is based on the author's experience and opinions. The author and publisher will not be held liable for the use or misuse of the information in this book.

TABLE OF CONTENTS

INTRODUCTION

◼ DIGITAL SLRS ARE BECOMING A REALISTIC OPTION

Until very recently, digital single lens reflex (SLR) cameras were highly specialized pieces of equipment used by photojournalists and a select group of photographers with big budgets and lots of patience. Early models had limited resolution, were cumbersome to

Digital SLRs are capable of delivering image quality equivalent to that of film cameras, but equal care must be taken when exposing and focusing. (Camera: Nikon D1x)

use, and extremely sluggish. On top of that, they were very expensive. It wasn't all that long ago that a professional-level digital SLR cost $20,000 or more.

Over the last few years, digital SLR resolutions have climbed, and the cameras have become considerably easier to use. Limitations like short battery life and slow removable-media write speeds have improved considerably. And prices have dropped to the point where just about any professional photographer (and many enthusiast photographers) can afford them. Now there are several digital SLRs on the market that are under $2000, and there's even a model available that costs less than $1000—about the same price as higher-end consumer digitals.

◼ SELECTING A DIGITAL SLR

Selecting any sophisticated camera can be a challenge; selecting a digital SLR is even more difficult. In addition to the things that have to be considered when buying *any* camera—exposure and metering controls, focusing systems, and capabilities under a variety of shooting situations, etc.—factors like resolution and responsiveness must also be taken into account, along with a variety of other new variables.

Digital cameras, in general, are more application-specific than film cameras. Because of their ability to accept interchangeable lenses and work with many of the same accessories that film cameras work with, the latest digital SLRs have (at least to a certain degree) broader capabilities than earlier models. There are still some models, however, that are targeted at specific market segments. For example, some digital SLRs are specifically designed to shoot action, while others are optimized to provide maximum resolution.

Flamingos and other wildlife don't hold their poses for long. To capture the fleeting instant, a digital SLR must have minimal shutter lag, the time between when you press the shutter release and the time when the camera makes the capture. (Camera: Nikon D1x)

sports photography have lower resolutions. That, in turn, can mean lower image quality. Until relatively recently, photographers using digital SLRs had to choose what was most important to them: speed or resolution. Even now, digital SLRs still aren't quite to the point where spending more will automatically guarantee the features and capabilities that photographers are looking for.

◼ THE GROWING FIELD OF DIGITAL SLRs

The digital imaging industry is an interesting one to watch. There's a continuous stream of technological advances and new-product announcements. Specs are being improved and prices are changing all the time. That makes it difficult for a company to make a splash with a new piece of equipment or even an entirely new product line, unless everything falls into place just right.

Attracting Professionals. Companies spend millions trying to build the buzz on new products. Getting professionals, in particular, to buy into one manufacturer's or another's system is very important. Even though they account for only a small percentage of the overall profits from camera sales, professionals are the trendsetters and opinion leaders to whom consumers tend to look.

Also, photographers are notorious for having favorite cameras and lenses. They like the idea of being able to move into digital by simply adding another body. Therefore, once a company has a professional using its gear, it also has a long-term customer who will probably regularly upgrade bodies, lenses, and accessories. Photographers do change equipment brands occasionally, but generally, once they're comfortable with their gear, they're reluctant to make abrupt changes. It's much easier for them to add another body or a new lens than it is to start all over again.

The exception, of course, occurs when a new digital body doesn't perform as expected. Then, the photographer will search for other ways of doing what he wants to get done. If it turns out that there are real problems, it could jeopardize that photographer's image of the entire brand. That's been the case with film, where photographers sometimes switched from Canon to Nikon, or vice versa, because there was a spe-

With film SLRs, when greater capabilities are required, it's usually just a matter of shelling out more money for a more sophisticated camera. A photographer might change from a short telephoto lens when taking portraits to a longer lens for shooting distant action, or from a wide-angle lens when shooting scenics to a lens with macro focusing capabilities to take close-ups, but the end product was pretty much the same.

With digital SLRs, there's more of a trade-off of camera features and capabilities for specific market segments. For example, in order to achieve maximum shooting speeds, some models designed for action and

cific piece of equipment, lighting gear, or lens that didn't perform as expected. That can be even more of a problem with digital cameras, as digital becomes the predominant shooting method. Companies that don't stay ahead of the digital curve risk not only losing sales on the digital side, but on all their photographic gear.

That's why the development of digital SLRs that compete effectively with film SLRs is deemed so important for camera manufacturers targeting the professional market. If they don't come up with digital SLRs that meet the needs of their professional customers, other companies might. And that could mean not only losing those customers on the digital side, but also on the film side, since photographers tend to want to shoot with interchangeable film and digital gear whenever possible.

Digital SLR bodies are now at the point where they can be integrated very effectively into complete camera systems. Increasingly, both film and digital bodies from the same manufacturer will accept the same lenses and the same accessories. While the effective focal length for lenses designed to be used with film bodies may be different when they are used with digital bodies (because, in most cases, the size of the image sensor is smaller than the size of a 35mm film frame), they do couple and focus on the digital SLRs. There are limitations, though, for using lenses that were designed for film cameras on digital bodies. They may not be quite as sharp when used with a digital SLR as they are when used with a film camera. That's why, more and more, manufacturers are designing and producing lenses that are specifically intended for their digital bodies.

Competition. Camera manufacturers try very hard to stay ahead of the game, or at least to keep up. It's not hard to imagine the dread within the halls of Nikon when Kodak, which was once its partner in producing digital SLRs, came out with a model on their own: the 14n, which had a Nikon lens mount and a 14 megapixel resolution. Canon's introduction of the 11-megapixel 1Ds certainly didn't help Nikon any. In fact, it sent company engineers scrambling for ways to somehow increase resolution without having to go to a significantly larger image sensor. Nikon came up with a software solution that helped somewhat, but it's still a software solution rather than an increased pixel count in the image sensor.

Companies are always looking over their shoulders to see who's gaining on them. At the same time, they are looking ahead, trying to overtake the market leaders. That's one of the reasons that there are a lot more digital camera models being introduced now than there ever have been film cameras. A company has to aggressively differentiate itself from the other camera manufacturers to gain a competitive edge. The rationale is that, if one digital camera model doesn't do it, hopefully another will.

■ ABOUT THIS BOOK

In this book, we will begin with some general information about digital SLRs for those new to the subject and for those interested in topics such as the differences between image-sensor types or the comparative speeds of CompactFlash cards. Topics in this chapter relate to all digital SLRs. Subsequent chapters give detailed descriptions of the controls and features of individual digital SLRs. The two manufacturers with the broadest lines of cameras, Canon and Nikon, have their own chapters. Other manufacturers are included in a subsequent chapter.

Thanks to the generosity of the manufacturers, we were able to test all of the cameras that are featured.

OLYMPUS AND PENTAX REBORN

The growing interest in digital SLRs by photographers has prompted a couple of companies that had pretty much abandoned the professional market, when it came to film cameras, to re-enter the field. They see opportunities there by targeting underserved photographers. While not traditionally the first choice for professional photographers, both Olympus and Pentax had been solid second-tier companies in the 35mm market. Both are now trying to convince serious photographers who are interested in adding digital capabilities to go with an entirely new digital system, while they continue to shoot with the film gear that they're already using. That's going to be a real challenge.

DIGITAL SLR-LIKE CAMERAS

All the cameras covered in this book are true digital SLR cameras with interchangeable lenses. The image that's displayed in the viewfinder is exactly the same as what's captured by the image sensor. When it comes to actually taking pictures, there's very little difference between what a photographer sees when shooting with a 35mm SLR and a digital SLR.

There are two other types of cameras, however, that are sometimes thrown into the SLR group. First are the digital SLR models that are real SLRs, such as the Olympus E-10 and E-20n. They are true SLRs, but they don't have interchangeable lenses. Again, the image in the viewfinder is what's being focused on the image sensor.

Second, there are digital cameras that are being advertised as "digital SLR-like" cameras. Theoretically, any camera with a preview LCD can display exactly what's being captured by the image sensor. Most of those aren't

Precise framing in the viewfinders of SLR-type cameras make it possible to capture detailed close-ups without having to be concerned about parallax distortion. It would be almost impossible to frame this shot of a dragonfly, taken with the Minolta DiMage 7i, with a standard digital camera viewfinder. Because LCDs are difficult to see in most daylight situations, it would even be difficult to frame it using the LCD on the back of a camera.

considered SLR-types because the preview images aren't displayed in the optical viewfinder. Some digitals are called "SLR- like" because they have two LCDs: one on the back of the camera and one in the viewfinder. That way, as with digital SLRs, the image that's displayed in the viewfinder is exactly what's being captured by the image sensor. Cameras like Minolta's DiMage 7 line of digitals, and the Olympus C-720 and C-740, fall into the dual LCD category.

The drawback for those types of cameras is that the viewfinder image is very much dependent on the quality of the LCD in that viewfinder. LCDs are frequently very low resolution. Some display as little as 120,000 pixels of digital data. A 5-megapixel digital image doesn't always display all that well on a 120,000-pixel screen. That can make it more difficult to frame and focus photos. With those cameras, it's also possible to review captured images on either the viewfinder LCD or the LCD on the back of the camera. That can be an advantage, since it's sometimes difficult to view captured images on LCDs on the back of cameras in situations where the light is bright or there's a lot of glare.

SLR-type cameras can have advantages built into them that conventional digitals don't have, such as long telephoto lenses. The series of horses on a Mexican beach was taken with the Olympus C-720UC, which has an 8× optical zoom. Standard coupled viewfinders couldn't have the extended range that LCD viewfinders are capable of.

However, not all of the digital SLRs were tested in the exact same manner. Rather, they were either tested for the applications that they were being targeted at by the manufacturer or for those applications to which they seemed best suited. For example, the Nikon D2H was tested for shooting action. With their high resolutions and high prices the Kodak 14n and the Canon 1Ds are most applicable for high-end commercial photographers, and were tested as such. On the other end of the spectrum, because of their size and weight, cameras like the Canon Digital Rebel and Pentax *ist D are great carry-alongs for shooting in the field or traveling on vacation. It would be unfair to compare them head-to-head with the higher-end models.

While every effort is made to give as much information about the individual camera as might be required to make an educated purchasing decision, the more complex the camera and its functions, the more detailed the specific camera sections are. The book includes photographs that we have taken with all the different models. Between the text and the photographs, we hope it will provide you with all of the information necessary to decide which digital SLR is best for the type of photography that you do.

1. GENERAL INFORMATION

■ IMAGE SENSORS

All digital cameras are designed around image sensors. They are an integral part of digitals, regardless of whether they're inexpensive point-and-shoot models, consumer models with various features and capabilities, prosumer models designed and priced for business applications, or professional models used for commercial, portrait, wedding, industrial, and editorial photography. Image sensors are digital cameras' equivalents to film.

When shooting with film, the image that is captured and stored on the film is called the latent image. In some respects, digital chips still capture a latent image, but in a totally different manner. Rather than using light-sensitive materials that have to be chemically processed in order to make those latent images visi-

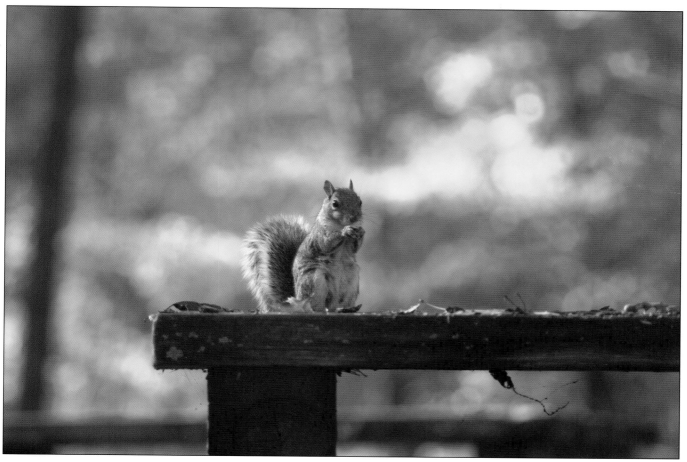

Because the image sensor in a digital SLR is generally smaller than a 35mm film frame, there is a multiplication factor when lenses designed for 35mm cameras are used. Here a 200mm/f2.8 lens becomes a 300mm/f2.8 lens for this wildlife shot. (Camera: Nikon D1x)

ble, they use individual sensors to capture the millions of picture elements (pixels) that make up a digital image. Instead of being chemically processed, these picture elements have to be processed electronically to be transformed into viewable images.

All electronic cameras, whether they are older 8mm video camcorders, new miniDV models, consumer still digitals, or professional digital SLRs, have image sensors. More than 100 million image sensors of all types are being sold annually, and the demand for image sensors is continuing to climb.

Size of Image Sensor. Just like there are different sizes of film, there are different sizes of image sensors. Image sensors designed into consumer cameras range in resolutions from 640 × 480 pixels, which is about a third of a megapixel, to 8 megapixels, with almost all sizes in between. Most of the higher-end consumer models have 5- or 6-megapixel image sensors. If they have some special capability, such as longer telephoto lenses, their resolutions might be 3 or 4 megapixels. Professional-level digital cameras have image sensors ranging from around 4 megapixels, such as the Nikon D2H, all the way up to 14 megapixels for the Kodak 14n.

How They Work. While image sensors are essential in digital cameras, they do not capture images digitally. Rather, they capture light with photo-diode sensors. The photons that strike the sensor are converted to a proportional number of electrons and stored in an analog format at each individual sensor position. The values of the individual electronic signals captured by those sensors are then converted either by the image sensor itself or by supporting electronics to an equivalent digital value. With most image sensors, each individual sensor position provides one pixel of digital data. The millions of converted digital values are combined to create the captured electronic image.

Types of Image Sensors. There are two types of image sensors: CCD (charge-coupled device) and CMOS (complementary metal oxide semiconductor). As noted above, image sensors capture light, then convert it to an analog signal that is stored at each individual sensor position. With a CCD, those electrons are then read electronically, sent to additional on-board electronics, and converted to a digital value.

Conventional CCD array.

For a long time, CCDs were the image sensors of choice for almost all digital-capture devices. They provide excellent image quality and relatively low noise, but they also require a specialized chip-construction process. Rather than having all the electronics on one chip, a separate chip set is required to handle support functions.

There has been some progress made in integrating other electronics functions into the CCD, but, for the most part, CCD digital cameras still require a considerable amount of supporting electronics. Depending upon the camera design, sets of anywhere from three to eight additional chips are incorporated in the camera's image capture, conversion, and processing routine. That makes it more expensive to produce digital cameras with CCD sensors than CMOS sensors. As CCD resolutions climb, so do both the cost of their production and the amount of support electronics required (which, in turn, tends to increase random electronic noise).

There are specialized implementations of CCDs, such as for Fuji's S2 or the Nikon D1x (which are covered in their respective sections), that provide higher resolutions than conventional CCD implementations. However, while CCDs are good at capturing images, they do have definite limitations.

Another type of image sensor that's becoming increasingly popular in digital cameras is the CMOS sensor. They're being used in some medium- and large-format digital backs as well as in professional digital SLRs and in some consumer cameras. There are similarities between CCD and CMOS sensors: both CCD and CMOS chips are made of silicon; both capture

light with similar sensitivity over the visible and near-infrared spectrum; and both convert incident light into electronic charge by the same photo-conversion process. However, they are different in design and operation. With CMOS, it's possible to produce entire digital cameras on a chip, since CMOS sensors, unlike CCDs, can be made of the same silicon material from which other computer chips are made. That significantly reduces production costs, space requirements, and power usage.

Like CCDs, CMOS sensors also have individual sensor elements. Unlike CCDs, though, where the analog signals are stepped off of the chip registry before they are converted to digital, the conversion of the electronic signal to a digital value is completed within the individual photo sensor. That makes it possible to read out the values of the individual sensors in a single step, rather than having to step the electronic signal off of the register, as is the case with CCDs. However, the light sensitivity of a CMOS chip is slightly lower than that of a CCD because space is needed on the chip for the transistors to process the signal. Because of this, some of the photons hitting the chip hit the transistors around the photodiode, rather than the photodiode itself.

CMOS sensors have only recently been getting a lot of attention, but they've been around for quite a long time. A type of CMOS sensor, called NMOS (n-channel metal oxide semiconductor) was used in the early 1970s in video cameras. They worked, but image quality was marginal at best. An unacceptably low signal-to-noise ratio (the ratio of useful image information to non-image information) has always been one of the problems with CMOS.

It's only been in the last few years that the limitations of the technology have been sufficiently overcome to make CMOS a viable alternative to CCD. The quality gap between images that are being captured with CCD sensors and images being taken with CMOS sensors is narrowing rapidly. That's particularly the case as digital camera resolutions climb, since CMOS sensors don't suffer as greatly from the decrease in the signal-to-noise ratio as resolutions increase. That means higher-resolution digital cameras can be produced without having to significantly increase the supporting electronics. One of the reasons that CMOS is finally taking off is that there are a large number of corporations, educational institutions, and governmental agencies working on the technology. With more than 60 organizations engaged in CMOS development, the size and quality of the images that those sensors can capture are increasing rapidly.

There are also specialized CMOS chips. One of the companies that's on the cutting edge of CMOS development is Foveon, which developed the X3 sensor chip (this is discussed in greater detail in the section on the Sigma SD10, which is designed around an X3 chip). A number of other digital camera manufacturers are also incorporating CMOS sensors into their models. Canon, in particular, has been aggressively implementing CMOS in its digital SLR design. Both the 1Ds, which, at a street price of around $8000, is one of the most expensive digital SLRs on the market, and the Digital Rebel, which, with a street price of $900, is one of the least expensive, utilize CMOS sensors.

■ RESOLUTION

The one thing that most people have heard about digital imaging is that resolution is important. To a certain degree, that's true. All other things being the same, the

TOTAL VS. EFFECTIVE PIXELS

With most image sensors, each individual sensor position provides one pixel of digital data. That doesn't necessarily mean that the resolution of the final image will be exactly the same as the total number of individual pixels on a chip. Because of the way that sensors are designed into digital cameras, and the need to have a background electron flow standard to match against the captured signal (as a way to eliminate background noise), some of the pixels on the sensor are cut out of the image frame. This accounts for the difference between the total pixel number quoted in most sales literature and the effective pixel number buried in the specifications. The important number is the number of effective pixels because it indicates how many pixels are used to produce the image.

higher the resolution of a specific digital image, the higher the quality.

Some image sensors for professional medium- and large-format cameras go as high as 22 megapixels. Kodak has built a line of 16-megapixel sensors that are used in a number of leading medium-format digital backs. The highest resolution digital SLR, the Kodak 14n, has a nearly 14 megapixel sensor, with the Canon 1Ds being close behind at 11 megapixels. The next lower level for professional SLRs is 6 to 8 megapixels. There are a number of models from different manufacturers in that category.

The resolution of a digital camera is actually the resolution of the sensor that's used in it to capture the electronic image. Multiplying the sensor dimensions provides the resolution. For example, a sensor with 480 rows of 640 pixels each (which is what's sometimes referred to as standard screen resolution) has a total resolution of 307,200 pixels. While aspect ratios may vary, 6-megapixel sensors have resolutions in the range of 3000 × 2000 pixels. With both CCDs and CMOS sensors (other than the Foveon X3), those megapixels are the total number of effective imaging pixels, not the numbers of pixels per red, green, or blue (RGB) color channel. (RGB stands for red, green, and blue, the three primary colors that digital cameras use to simulate the full range of colors we see.)

■ FILTER ARRAYS

Bayer Filters. The image-sensor elements themselves are only sensitive to the amount of light striking them (luminance), not the color of the light. In order to create color, this light must therefore be differentiated into red, green, and blue. With most digitals, this is done using mosaic filters. These filters, called Bayer filters after Dr. Bryce Bayer of Eastman Kodak who developed them, are bonded to the image sensors using a photolithography process that adds color dyes. Bayer filters consist of a checkerboard pattern with alternating rows of filters. One row will alternate red and green filters while the row below will alternate blue and green (see illustration above). In a complete array,

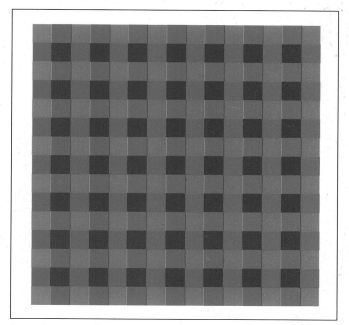

Bayer filter array.

there are as many green pixels as red and blue pixels combined. This is necessary because the eye is more sensitive to green light, so more green information is needed in order to create an image that the eye will perceive as accurate in color. Digital cameras use specialized algorithms to convert the separate colors into an image.

Micro-Lens. In some cameras, not only does each sensor element have a filter bonded to it, it may also have a micro-lens bonded to it in order to focus and concentrate the light, improving image quality and sensitivity. Many CMOS-based sensors, other than the Kodak 14n, use these micro-lenses over the sensor elements, as do all CCD sensors.

Infrared Filter. Two additional filters are frequently used over the entire sensor array. Since the photodiode image sensors are overly sensitive to infrared radiation, an infrared (IR) filter, which gives the sensor a cyan color when you see it in the camera, is mounted over the sensor.

Anti-Aliasing Filter. When photodiodes sample information, they see a sharp distinction between dark and light and are unable to sample all of the high-frequency information. Therefore, when the color infor-

FACING PAGE—Tropical sunsets, with softly gradated colors in the sky, can be a problem with consumer digitals. The high resolutions and large chips in digital SLRs make it possible to capture them without problems. (Camera: Fuji S2)

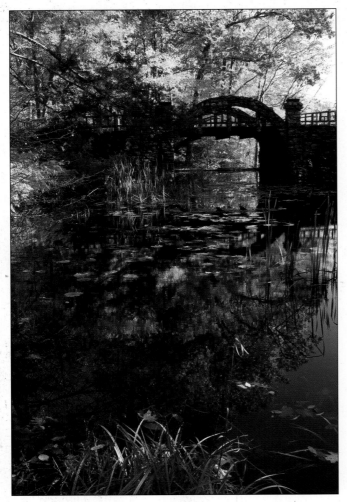

Modern digital SLRs can rival—and sometimes surpass—film cameras in their ability to capture the full range of colors and values in a scene.

(Tagged Image File Format) and JPEG (Joint Photographic Experts Group) formats, as well as a proprietary RAW format. Each format has its advantages and disadvantages, and choosing the best format for the photography you will be doing is important.

TIFF. The quantity of information coming off of the imaging sensor in a digital SLR camera is very large. A 6-megapixel sensor creates an 18MB file (six megapixels times three for the red, green, and blue values) when the information is stored as 8 bits for each of the three colors, as it is in the uncompressed TIFF format. Since no compression is applied to the file, no image data is discarded that would have to be reconstructed later when the image was uncompressed, so a very high-quality image is captured.

However, this large image has several disadvantages: it takes longer to write to the storage card, fewer images can usually be captured in a burst, and the card (no matter what the capacity) will hold fewer images than if the information were stored in other formats. TIFF files do have the advantage of being generally compatible with a wide range of imaging programs, so they can be opened directly from the storage card. If a high-quality, 24-bit image that can be immediately opened in an imaging program is more important than file size to your work, then shooting in TIFF mode is appropriate.

JPEG. JPEG files, on the other hand, are much smaller than TIFFs since they are compressed before being stored. Digital SLRs offer two or more levels of compression for JPEGs.

Compared to other file formats, JPEG compression generally increases both the maximum number of captures in a burst and the capture rate of the camera as well as the number of images the storage card will hold. However, information is lost during compression that may or may not be accurately reconstructed later in the computer. At the finest JPEG settings, generally a compression ratio of approximately 1:4, the image quality for many subjects is still very good, and the number of images that the card will store increases by

mation is interpolated, extraneous data is created. This results in moiré patterns or randomly colored pixels in monochromatic areas and specular highlights. To minimize these, an anti-aliasing filter is also mounted over the sensor. Unfortunately, the only way to reduce anti-aliasing is to reduce the high-frequency information—and that means reducing sharpness. The Kodak 14n camera and Foveon X3 sensor do not use an anti-aliasing filter.

▪ FILE FORMATS

Digital SLRs offer a choice of file formats in which to save images. Most include the widely compatible TIFF

FACING PAGE—Polarizing filters have the same effect with digital cameras as film cameras. The image on the bottom shows the scene without the filter and the image on the top shows the effect of the polarizing filter. Only circular-polarizing filters should be used with digital SLRs to ensure all of the autofocus and exposure functions will operate properly.

 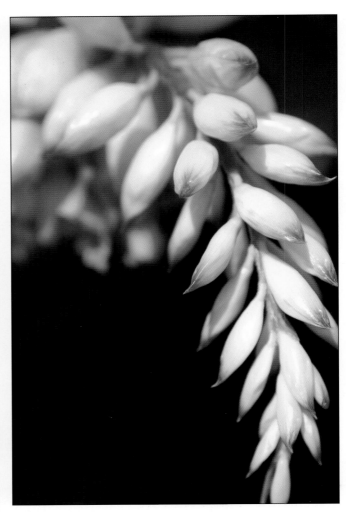

Close-up photos of flowers are often easier with digital SLRs since they provide immediate feedback of the captured image, while still allowing the exact framing of an SLR. (Camera: Nikon D1x)

a factor of four or more. When the important considerations are speed of capture (such as when shooting sports), or capturing a large number of images without changing storage cards (such as in underwater or wildlife photography), JPEG files may be the best choice.

The latest JPEG format, JPEG2000, utilizes a "less lossy" compression algorithm to reduce image size. Although some imaging programs support JPEG2000, it has yet to find its way into digital SLRs. Look for it to be implemented in future cameras.

RAW. Digital SLRs offer another option for image capture storage: RAW files. When you take a picture with a digital SLR camera, the picture information from the image sensors is captured in 12 bits per color. To save the file as either a TIFF or JPEG image, that information is then processed in the camera to 8 bits per color. While this processing is occurring, other changes are permanently incorporated into the file—including the photographer's selections for white balance and resolution among others.

RAW files differ from TIFFs and JPEGs because the photographer's selections are not a permanent part of the file, but are simply associated with the raw, 12-bit sensor data in a proprietary format. This file format requires software, available from the camera's manufacturer (and some third-party vendors for an additional cost), in order to convert this data into an industry-standard graphics format.

While this additional processing step and its associated cost is a disadvantage for some, professional photographers will generally shoot in RAW format because of its many advantages. Chief among these is the fact that the file contains 12 bits of information per color rather than eight. This additional color informa-

tion improves image quality when adjustments are made to the image before saving it in another image format. Nearly any adjustment that can be made in the camera before the capture can be made after the capture to the RAW file. It is possible to change white balance, fine-tune color temperature, alter hue and saturation, and adjust gray balance. In addition, all of the levels and curves controls found in image processing programs are available. Once the changes are made, the file can be saved in its RAW format, becoming a "digital negative" for archiving since the raw sensor data is still unchanged—the settings are still only *associated with* the data.

Where the maximum amount of control over the image is more important than the additional time and effort (and software requirements) needed to process the image file, capturing in the camera's RAW format is the way to go.

■ SOFTWARE

All digital SLRs include a CD-ROM containing software to view the files made by the camera. The same program, or a compatible one that is also included, allows the enhancement and conversion of the camera's proprietary RAW-format files to TIFF and JPEG formats. Many manufacturers sell other software programs as an option to their digital SLRs. These programs may offer increased control over the RAW files, the ability to control the camera directly from a computer, the ability to capture images directly into the computer from the camera, or combinations of these.

The rapidly-increasing market for digital SLRs has attracted the attention of third-party software developers who have created programs to supplement or replace those offered by the camera manufacturers. Several are worthy of mention. At the present time, many of these programs do not support all of the cameras discussed in this book, but support may be added in the future. Most of them offer free trial downloads. Visit their web sites for full information. (A list of web sites is included in the back of the book.)

Photo Mechanic is a fast and easy-to-use image browser for digital camera files. The program is popular with photojournalists and professional photographers who appreciate its innovative batch captioning, renaming, and speedy browsing. Photo Mechanic displays the "thumbnails" of photos on a camera disk or folder in a familiar "contact sheet" display window. You can quickly rotate, preview, copy, delete, tag, rename, and add caption or keyword information to photos both individually and in batches. It is available for select Windows and Mac operating systems.

Wide-angle photos are still possible with digital SLRs, but you need to resort to a 17mm focal length in order to get the field of view that a 24mm lens would give in a 35mm film camera. (Camera: Nikon D1x)

A number of programs offer RAW file conversion as well as image browsing. These include Adobe Photoshop, Bibble, Capture One Digital SLR and SilverFast DCPro.

The goal of software programs Bibble (for Windows) and MacBibble is to provide support for the viewing, manipulation, and conversion of RAW files from all cameras that produce them. Both programs feature a simple user interface and very fast processing of RAW files compared to the processing speed in the manufacturers' supplied software.

The Danish company Phase One makes some of the most popular high-end, medium-format digital backs on the market. The popularity of their equipment has a lot to do with the quality, functionality, and ease of use of their software. Phase One has incorporated their knowledge of photographers' workflow needs into several programs in the Capture One (C1) digital SLR family for enhancing and converting RAW files.

SilverFast DCPro is available as a stand-alone program as well as a Photoshop plug-in. Its virtual light table provides the user with the capability to effectively view, organize, and manage their digital image files. The application also provides essential image correction tools, such as red-eye removal, color correction, white balance, and exposure adjustment, as well as RAW file conversion.

These are just a sample of the more popular programs presently available. Each has its own strength and its own set of capabilities that might not be available with the software that comes bundled with digital SLRs.

Adobe Photoshop has become the standard in high-end digital imaging software. The latest version, Photoshop CS, includes a much-improved file browser that reads most of the popular RAW file formats. This version of Photoshop also incorporates and improves upon the RAW file conversion plug-in that had been available for Photoshop 7. In Photoshop CS, RAW files open in a special editing window with a wide variety of controls familiar to Photoshop users,

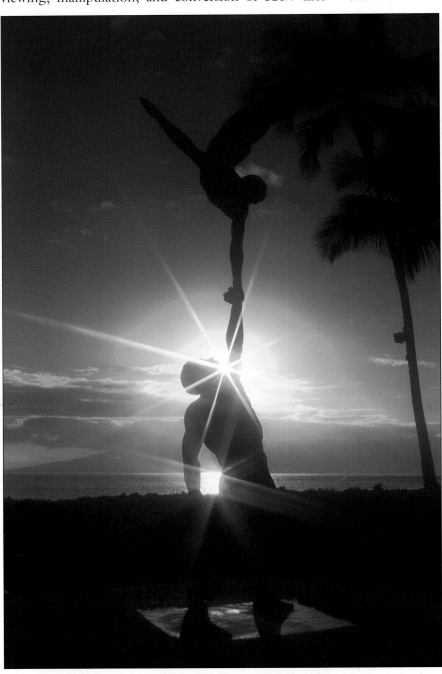

Because the camera is a SLR, you can see the effect of a star filter and position it exactly where you want it. Autobracketing with the camera set on continuous captures ensures that you will have a range of exposures from which to choose, all captured quickly without moving the camera. (Camera: Nikon D1x)

One advantage of digital cameras is that they allow you to capture close-up flower images in full sunlight at low ISO settings, then make available-light captures at high ISOs immediately after. This would be impossible with a film camera without changing films. (Camera: Fuji S2)

and the corrected file is saved in one of the many industry-standard graphics file formats.

◧ COLOR SPACES

We live in a color world. Digital SLRs allow photographers to capture the colors in our world and reproduce them on a computer monitor or in a print. How accurately the colors we see are reproduced depends in large measure on the color space the camera uses to capture the image. To understand color spaces, imagine a cube containing all possible colors, with the most saturated colors at the corners of the cube. A balloon blown up inside this cube would represent a color space. If a balloon were only partially inflated, it would include fewer colors and less saturated colors than a balloon that was more fully inflated.

Digital SLRs offer at least two color spaces, sRGB and Adobe RGB. Returning to the example of the balloon within the cube, the less-inflated balloon would represent sRGB while the more fully inflated balloon would represent Adobe RGB.

The sRGB Color Space. Hewlett-Packard, in conjunction with Microsoft, developed the sRGB standard for web images displayed on low-end color monitors. Because sRGB is the default setting on many digital cameras, the sRGB color space has also been the standard color space for Exif (Exchangeable Image File Format) and DCF (Design rule for Camera File sys-

The RGB color space.

tem) compatible devices, ExifPrint, kiosk printers, and some minilab digital photo printers. If the images you capture are intended for viewing or output on these devices, the sRGB color space is the correct setting.

The Adobe RGB Color Space. If, however, the images are intended for enhancement and printing at home on a high-quality inkjet, or for commercial offset printing, then the Adobe RGB color space is a better choice since it contains a wider range of colors. Adobe RGB was designed to contain most of the colors that commercial CMYK (cyan, magenta, yellow, and black) printers could reproduce.

Choosing the Color Space. The important consideration with color spaces is to match the input to the output color space in order to avoid surprises. Color information lost in a smaller color space such as sRGB cannot be recreated by saving the file in a larger color space such as Adobe RGB. It is always best to save images in the color space with the widest gamut, then save copies of them in lower-gamut color spaces for output, unless the file will be sent directly to a device that uses the lower-gamut space.

◼ REMOVABLE MEDIA

With very few exceptions, digital SLRs use Compact-Flash (CF) media to store the images they capture. Some models, however, are able to take other types of media, such as SmartMedia/MMC (multimedia) cards.

Type I and II CF Cards. There are a variety of CF cards available in different capacities and different speeds, but there are two broad categories: Type I and Type II. The primary difference is in the dimensions of

the cards, with Type II cards being slightly thicker. Generally, higher capacity cards, cards over 1 GB, are Type II.

Microdrives. There is also a subcategory of Type II CF cards, called Microdrives. Developed by IBM, Microdrives are now being marketed by Hitachi. These are fully functional miniature hard drives. While they were designed to be more rugged than normal computer hard drives, they are still more sensitive to shock damage than other types of CF cards and they consume more power.

Performance. One reason that CF cards are the media of choice for digital SLRs is that they are an intelligent removable media option. Unlike media such as SmartMedia that are basically just non-volatile memory, CF cards include an on-board controller that facilitates read–write operations. The final speed of the read–write operations of individual CF cards depends as much on this controller as it does on the flash memory modules. Companies like Lexar and SanDisk make their own controllers, ensuring consistent write speeds from card to card. Similarly sized cards from companies that buy controllers from a variety of sources could vary in speed from card to card.

Besides marketing cards with varying speeds, major CF card manufacturers have also optimized some cards to perform better with certain digital cameras. For example, some of Lexar's cards (those labeled "write acceleration") are optimized to handle data-writing functions more quickly when used with compatible digital SLRs.

In order to see just how much of a difference there is in write speeds between cards from different manufacturers, and different CF lines from the same manufacturer, we tested nine cards. These included a Simple-Tech ProX 512MB, a Kingston 1GB, a SanDisk Extreme 1GB, a SanDisk Ultra II 512MB, a Transcend 45× 1GB, an IBM Microdrive 1GB, a Lexar Professional 1GB, a Lexar Professional 512MB, and a Lexar 12× CF 512MB. To ensure that the test of write speed would give fair, accurate, and repeatable results, the following methodology was adopted:

- Tests were done with a Nikon D1x powered through an AC-adapter so that battery power

level would not be an issue. Before each card was tested, it was formatted in the camera. A record was made of the formatted capacity for RAW files as indicated by the D1x.

- The camera was equipped with an enhanced buffer, so that 15 RAW NEF files (Nikon RAW files have the exptension .NEF) could be shot in a burst. RAW files were used because this is the file format most professionals are using. Write times using TIFF files would be longer since the files are larger. The camera was set for continuous firing. Exposure was set on manual, with a shutter speed of $\frac{1}{1000}$ second. The lens cap was left on the camera. This eliminated any variables that might be introduced by photographing an actual scene.

- The D1x was triggered electronically with a Nikon MC-20 remote cord and an electronic timer was started at the same time. The button on the MC-20 was held down until the camera would take no more exposures, then released. The timer was stopped when the green light on the back of the camera indicated that the write cycle was completed.

- It was originally planned to reformat each card and repeat this procedure three times, then average the results. However, each card was only

Because you can capture many more images on a high-capacity storage card than on a roll of film, you tend to take pictures that you might not have taken with film. Sometimes they turn out to be keepers. (Camera: Nikon D1x)

COMPACTFLASH CARDS

COMPANY	CARD NAME	TYPE	SIZE	FORMATTED CAPACITY (NUMBER OF NEF FILES)	TIME (MIN:SEC)
IBM	MicroDrive	II	1GB	132	1:20
Kingston		I	1GB	111	0:52
Lexar	Professional 40x	I	1GB	125	0:46
Lexar	Professional 40x	I	512MB	62	0:44
Lexar	12x	I	512MB	62	1:06
SanDisk	Extreme	I	1GB	125	0:50
SanDisk	UltraII	I	512MB	62	0:49
SimpleTech	ProX	I	512MB	62	1:32
Transcend	45x	I	1GB	125	0:52

timed twice because the results on the second timing of every card were absolutely identical to the results of the first timing of the card. The results are shown in the accompanying table.

Other CompactFlash manufacturers than those listed were asked to submit samples for testing but did not have samples available. It's important to remember that advertised write speeds can be the minimum or maximum write speed supported by a specific card. Some companies guarantee a minimum write speed while others support write speeds up to the advertised limit. It's best to go with a card that guarantees the minimum sustained write speed. "Up to" a certain speed in any card advertisement may mean that the card is considerably slower than the maximum speed.

CompactFlash card capacities will continue to climb. Several companies have announced 4GB cards. One off-shore firm said it had a 6GB CF card almost ready to ship, but there was no specific time mentioned. Also, as card capacities increase, per-megabyte prices will continue to come down.

■ CONNECTIVITY

Digital SLRs include either Universal Serial Bus (USB) or FireWire/IEEE 1394 ports, or both, in order to transfer image files from the media card on which they are stored to a computer. Both of these connectivity standards were designed for computers to replace exist-

ing computer ports (parallel, serial, SCSI, mouse, keyboard, etc.).

USB. USB comes in two flavors, the original (and more common) USB 1.1, and the latest, USB 2.0. USB 1.1 can transfer data at the maximum rate of 1.5MBps (megabytes per second) while USB 2.0 offers a maximum transfer rate of 60MBps. USB 2.0 devices are backward compatible with USB 1.1 computer ports, but only transfer data at the slower USB 1.1 rate when connected to this type of port.

FireWire. The FireWire specification, which actually predates USB, was originally developed by Apple Computers for high-speed video transfer, and later became the IEEE 1394 standard on the PC. It provides a maximum data transfer rate of 50 MBps and is better suited to higher bandwidth applications like still- and video-camera data transfer. Apple has developed a new standard, called FireWire 800 (IEEE 1394b), found only on Macintosh G5 computers. It provides a maximum data rate of 100MBps as well as some other advantages. Future implementations should bring the data transfer rate closer to its theoretical maximum of 400MBps. When using a camera equipped with a FireWire port and a computer that accepts this standard, using FireWire will provide the fastest transfer of images directly from camera to computer.

Card Readers. An alternative for fast data transfer from cameras with only USB 1.1 ports is to purchase a FireWire or USB 2.0 card reader, remove the media

card from the camera, insert it into the card reader, and transfer the data at the faster rate.

■ COMMON PROBLEMS

Shutter Lag. One of the biggest complaints with digital SLRs is what's generally referred to as shutter lag. Shutter lag is the time between when the shutter button is pressed and when the shutter actually trips. With consumer digitals, that can sometimes be as long as a half a second, which can make the difference between being able to capture the framing of the composition as intended or not. Longer lags can mean the difference between getting a usable shot and junk. Even a slight delay can be a problem, since the composition will be different than what was intended.

Shutter lag isn't the result of one specific problem. Rather, it is usually a result of several different factors. With inexpensive digital cameras, it's often caused by the camera's slow electronics. The camera takes too long to make the exposure adjustments and set the focusing. In such cases, the lag is relatively consistent, but it can be quite long. With a consistent shutter lag, it's at least possible to anticipate the unfolding action in the viewfinder and press the shutter release slightly before the optimum time.

There's another type of shutter lag. That's when the camera has a problem focusing on a specific subject. That can be a problem with both inexpensive and expensive digitals. It might be a matter of not finding the right object to focus on, or jumping back and forth between two objects in the composition. With focusing problems, shutter lag can be very inconsistent. Sometimes the camera will respond quickly; other times getting it to fire will take more time. That makes it more difficult to antic-ipate the action, and more probable that the optimum moment will be missed.

Focusing delays have been reduced with the newer digital SLRs reaching the market, but they can still occur.

Write Delay. There are other delays that are common when using digitals—even more expensive digital SLRs. One is write delay, the time between when an image is captured on the sensor and the time that it is written to the removable media card. When an image is shot, however, it is not written directly to the media card. It is first transferred to the camera's internal

It is possible to use the full range of effects filters on digital SLRs that you would use with film, like the Cokin sunset filter used in the top photo. Set the white balance to something other than auto (the daylight setting was used here)—otherwise, the camera will try to correct for the effect of the filter. The bottom photo shows the scene without the filter. (Camera: Nikon D1x)

buffers, memory chips that hold captures that are waiting to be written to the media card. Generally, the more expensive the camera, the larger the buffer; the larger the buffer, the more images can be captured per burst or sequence of shots. A camera will continue firing for as long as there's room in the buffer. Once the internal buffer has been filled, the digital data that's stored in it has to be written to the removable media. That can take just a few seconds, or 30 seconds, or more. In most cases, it's possible to continue firing individual frames again as the previous images are pulled off of the buffer onto the card.

In general, a digital SLR's electronic and mechanical components determine just how many frames per second and how many frames total can be captured. In some cases its only possible to shoot one or two frames per second, but with some models, like the Nikon D2H, you can shoot as many as eight. That makes it competitive with film SLRs when it comes to frame rates. In most cases (again, except for the D2H), digital SLRs can't shoot as many frames continuously as a film camera. With film, it's possible to continue a rapid sequence of exposures for as long as there are frames left on the roll. With a digital, you can only take as many frames as the buffer will hold. For some cameras, such as the Sigma SD10, that could only be four high-resolution frames.

Once that buffer has been filled, camera action can become very sluggish. It's not possible to continue shooting until there's more room in the buffer. Photographers who added professional digital capabilities early on in the evolution of digital were frequently frustrated with their cameras precisely because of the long delays between when the buffer was filled and the camera was ready to shoot again. Things have gotten a lot better in the last few years.

■ SHOOTING DIGITALLY

Things have gotten a lot better in the last few years. The new generation of digital SLRs can finally compete effectively with film cameras in responsiveness and over-all shooting speed. It has finally gotten to the point that photographers don't have to give up performance to get the significant cost savings that can be realized by shooting digitally.

2. CANON DIGITAL SLRs

Canon released its first digital SLR, a model based on its 35mm EOS, in 1993. By the mid 1990s, Canon and Kodak were working together to develop digital SLRs.

This partnership developed a number of revolutionary models, including various versions of the EOS DCS 3, a professional digital body based on the Canon EOS-1N. It was designed around a 1.3-megapixel CCD that had a maximum resolution of 1268×1012. Black & white, infrared, and color models were available. These were actually quite advanced cameras that featured 12-bit per color channel image capture, adjustable ISOs, multiple shooting modes, and advanced focusing systems.

Canon and Kodak continued their relationship for a number of years. In early 1998, Canon released the EOS D2000, which was basically the same as the Kodak DCS 520. It not only had a maximum resolution of 1728×1152, but also professional capabilities such as a shutter-speed range that extended all the way from $\frac{1}{8000}$ of a second to a full 30 seconds. At the end of 1998, Canon brought out the D6000, which was also marketed as the DCS 560 by Kodak. It had an even higher resolution of 3040×2008 pixels.

Just how large the long-range potential market for digital SLRs is, is anybody's guess, but sales are climbing rapidly. For the year 2004, Canon expects to sell more than 500,000 digital SLRs worldwide.

■ CANON EOS 1DS

Professional photographers have been waiting for a long time for a digital SLR that can compete effectively with 35mm film SLRs when it comes to shooting speed and image quality. Canon's EOS 1Ds may not have been the ultimate answer when it was introduced, but it sure went a long way. As one of the most impressive digital SLRs on the market, it provides shooters with the right combination of image quality, resolution, and advanced shooting features. Sophisticated autoexposure, precise metering, and fast focusing make it a good choice for any photographer who needs very

The current family of Canon digital SLRs. Left to right are the EOS 1Ds, EOS 10D, and the EOS Rebel.

Canon 1Ds

high resolution but, because of shooting requirements, doesn't want to go with a medium- or large-format back.

Image Sensor. It's designed around a Canon-produced 11.4 megapixel CMOS sensor with an effective size of 11.1 megapixels. It has a maximum resolution of 4064 × 2704 pixels and a frame size of 35.8mm × 23.8mm. The image quality is further enhanced by the use of smaller pixels—only 8.8 microns each. (The pixels in the sensors used in previous models of Canon digital SLRs were 11.5 microns.) The only other camera that can compete with that is the Kodak 14n, which has a slightly higher resolution. Images are captured and converted at 12-bits per color channel for extra smooth gradients and color transitions.

Shooting Speed. Another category that the 1Ds is very competitive in is speed. There's virtually no shutter lag, as there frequently is with some higher resolution digitals—even some professional models. It can capture up to three frames per second to a maximum burst rate of 10 frames. Redesigned electronics, including a new two-channel data reading system, have significantly increased throughput over previous models.

Shooting Options. The 1Ds has a comprehensive selection of auto and manual shooting options. Shooting modes include manual, shutter-speed priority, aperture priority, and program AE (autoexposure). Exposure bracketing to ±3 stops, in ⅓-stop increments, is also available. The dial next to the shutter-release button serves as a shutter-speed dial in the manual and

The 1Ds is very responsive, so you don't need to worry about shutter lag. Capturing a flag at the optimum flutter position is a good test to see just how responsive a digital camera is.

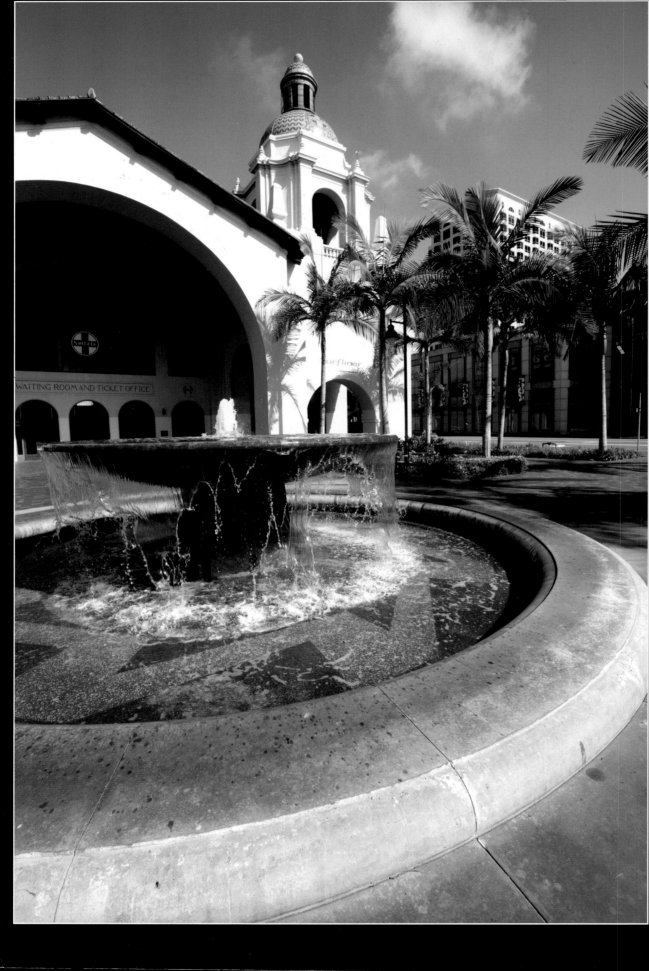

shutter-priority shooting modes. In the aperture-priority mode it sets the aperture, and in the program-AE mode it shifts the exposure program. In the manual mode, the dial on the back of the camera is used to select the aperture, while it turns into an exposure-compensation dial in the program-AE mode.

The 1Ds comes equipped with a 21-zone evaluative exposure-metering system with both autoexposure bracketing and white-balance bracketing. Metering options include multi-spot, central spot, focusing-point linked spot, and central-weighted. Advanced capabilities, such as being able to automatically average exposure readings from up to eight points for highly accurate exposure readings, are available.

A hybrid auto white-balance (WB) system utilizes both the CMOS image sensor and a separate external sensor for very precise color renditions. The white-balance temperature range starts at 2,800 Kelvin (K) and goes up to 10,000K in 100K increments. Ten different white-balance settings, including auto, daylight, overcast, cloudy, tungsten, fluorescent, and flash, as well as custom options and personal settings, ensure just the right color under different and difficult lighting conditions. White-balance bracketing (±3 steps) is available.

It has both auto- and manual-focusing capabilities, with focusing options including a single-shot mode

and an AI-servo mode (designed to maintain focus while following action). The autofocus EV range is 0–18 at 100 ISO. The 1Ds has a sophisticated 45-point area autofocus system that is linked to the 21-point evaluative metering system for precise focusing. The focusing points are in a central area AF ellipse, with individual focusing points for those parts of the image that are in focus being highlighted.

There are three LCDs on the magnesium-alloy camera body, including the color image preview/review LCD, and two monochrome data LCDs, one below the image LCD, and a somewhat larger one on top. A new 25×-enlargement option for reviewing

ABOVE AND RIGHT—It's possible to take wide-angle photos with the 1Ds, because the lenses have the same coverage as they would have on a 35mm SLR. When shooting at 28mm, the 1Ds provides the type of coverage that photographers are looking for when they shoot wide-angle images.

FACING PAGE—The CMOS sensor is large enough so that there's no conversion factor involved when using Canon lenses that were designed for film cameras.

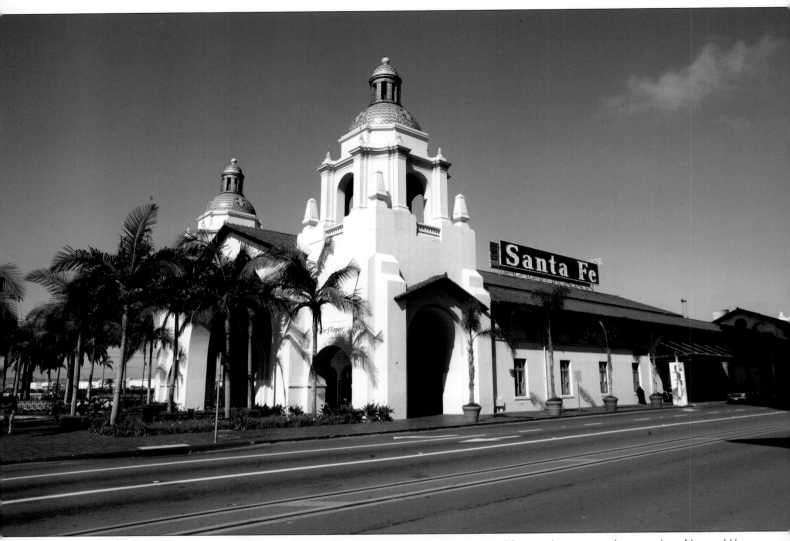

Because the images that the Canon 1Ds can capture are very high resolution, they can be used for just about any application where film would be have been used previously.

images makes it possible to closely inspect captured images without having to download them to a computer first. A histogram is available on the color LCD during image review.

Camera Settings. A set of five buttons to the left of the two LCDs on the back are used to set the camera's menu options. There are four main menu screens: the setup menu, the record menu, the playback menu, and the custom functions menu.

The setup menu is used for getting the camera ready to shoot, as well as for such tasks as formatting CF cards, cleaning the sensor, and updating firmware.

The record menu includes white balance, color temperature, file format, and color matrix selections and similar adjustments. The five color matrix options

provide selections from multiple color characteristics and two different color spaces (sRGB and Adobe RGB), simplifying color management and digital output. It's also possible to store three separate sets of image-processing parameters as part of the color matrix. Compression ratios, tone curves, and image optimization settings can be stored in memory.

The playback menu has all the expected options for displaying and protecting images. There's also a highlight alert where overexposed areas of a composition will blink on and off.

The final option, the custom functions menu, gives the 1Ds lots of its power, providing access to all of the camera's custom and personal functions. Designated as C.Fn-#s in the menu structure, the 21 custom function

options set things like the AI-servo tracking sensitivity, the shutter-curtain synchronization, and various metering options. The 26 personal-function options are designated as P.Fn-#s in the menu structure. They set things like minimum to maximum shutter speeds and aperture values, and the number of shots in a bracketing sequence. That makes it possible to personalize the camera for specific requirements. There's also a noise-reduction option that's used for exposures that exceed one second. The menu structure is easy to figure out, but reading menus on the color LCD is difficult. Too much information is squeezed onto each screen, making menus sometimes difficult to read. Other buttons on the back, individually or in combination, can be used to make quick changes to some of the settings.

The ISO settings on the 1Ds go from 100 to 1250 ISO. A lower ISO of 50 is available as a custom function. Shutter speeds range from 30 seconds all the way up to $\frac{1}{8000}$ second. A shutter release in the base's vertical grip makes it easy to shoot portraiture and other vertically framed subjects.

The 1Ds is a complex piece of equipment, but despite all its settings, options, and controls, it really doesn't take all that long to get used to. It certainly isn't any more difficult to get started with it than most high-end consumer digitals. In fact, because all the options are readily accessible without having to page through numerous layers of menus, in some respects, it's easier to use than many lower-resolution, lower-priced models.

Flash. The 1Ds can take Speedlite EX series E-TTL autoflash. There's also a PC cord terminal for studio flash, which has a maximum sync speed of $\frac{1}{250}$ second. The built-in microphone lets users attach up to 30 seconds of audio data, such as voice annotations, to individual files as they are captured.

Removable Media. The camera stores images on CompactFlash memory cards, including Type I, Type II, and Microdrives. The smallest capacity that should be considered is a 128MB card. You can store only five RAW files, 26 low-compression JPEG files, and 62 high-compression JPEG files at the maximum resolu-

Canon's proprietary CMOS sensor captures bright, vibrant colors with very little artifacting.

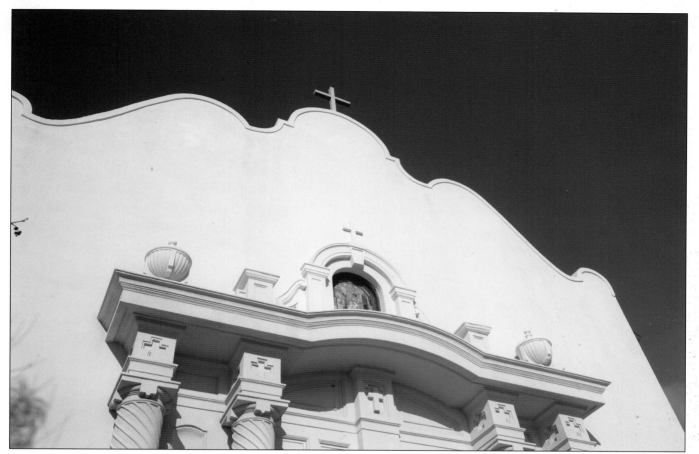

CMOS sensors have a reputation for capturing low-contrast photos. But the images that the 1Ds was able to take were well within the range of brightness, contrast, and color rendition for professional applications. Only standard post-processing was required.

tion on each 128MB card. It's possible to write both a RAW image file and a JPEG file onto the CF card at the same time. It's also possible to shoot at a 2.7-megapixel resolution with low compression. Seventy-two of these lower-resolution files fit on a 128MB card. For serious shooting, it's a better idea to go with a much higher capacity card. A 1GB CompactFlash or Microdrive card can store 59 RAW images. That's a little less than two rolls of 35mm film.

Viewfinder. The viewfinder provides 100 percent coverage, so there isn't the framing frustration that can occur with viewfinders that display less than what the sensor captures or extend beyond the active frame area. Diopter adjustments from −3.0 to +1 are available. Like more advanced 35mm-type SLRs, the 1Ds accepts interchangeable focusing screens. Nine are currently available.

Lenses. Also, you don't have to be concerned about lens conversion factors, which are common with digital SLRs that have been designed to be part of film-camera systems. These conversion factors result from sensors that are smaller than a conventional 35mm film frame and result in a change in the effective focal length of the lens. This is not only inconvenient to work with, it makes it very difficult to do wide-angle photography, since the conversion factor increases the effective focal length of all your lenses (making them less wide angle). Using the 1Ds with the 16–35mm zoom lens that was supplied with the body, however, made it possible to do serious wide-angle work.

Weather Resistance. The 1Ds is well suited for shooting under adverse conditions. The camera is advertised as being "water resistant." Extensive gasketing gives it a certain level of weather resistance, but it shouldn't be taken for waterproof.

Documentation. The documentation with the 1Ds is thorough and generally well written, but probably the most helpful piece of documentation is the tri-

fold *Quick Operations Guide* that ships with the camera. It covers just about every operation, much of it in detail, without getting bogged down in the complexity of the equipment. Virtually every menu option, setting, and informational screen is explained. Controls for such important settings as white balance, selecting the shooting mode, and determining the focusing point are all detailed and diagrammed in a step-by-step manner for easy operation.

Battery. The camera pulls its power from a rechargeable NiMH. It's also possible to use AC power in the studio. A single charge lasted more than 600 frames, and the recharge time was very quick.

Remote Firing. A remote switch and wireless controller are available.

Software. The 1Ds comes bundled with a new release of Canon's File Viewer utility, which comes in both Mac and Windows versions. It can be used to process captured RAW images into extremely high-quality, 16-bit per channel TIFF files, conventional 8-bit per channel TIFF files, or JPEG files. All the post-image processing that is generally handled in the camera can be applied by the software. It can also be used to add image-captioning information. The camera supports both FireWire and USB connectivity. Canon's RemoteCapture lets photographers control the camera from any Mac or Windows system. Special capabilities such as interval shooting can also be handled from a personal computer.

Conclusion. All in all, the 1Ds performs exceptionally well, even under difficult lighting and shooting conditions. There's no question that it provides many of the features and capabilities that professionals are looking for. On the downside, with a price of just under $8000, it's a little too high for the professional photographer, who would make the best use of it. With dimensions of 6.1" × 6.2" × 3.1" and a 44.1-ounce weight, it's also a little on the heavy side. Still, it is quite competitive with other high-end cameras, even some medium- and large-format models. —*RE*

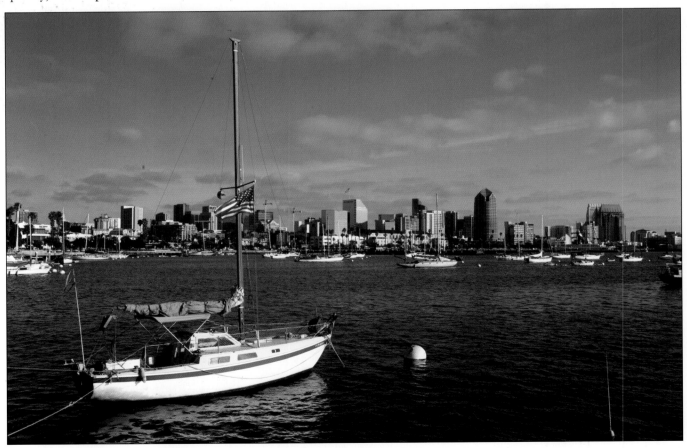

When taken in the RAW format at maximum resolution, a shot like this one of the skyline of San Diego could be blown up to poster size without significant loss of detail.

Canon's EOS 10D produces images with exceptional color rendition and good contrast.

■ CANON EOS 10D

Canon's EOS 10D is a digital SLR with professional capabilities, but it's still within the budget of almost any serious photographer. It has some of the same capabilities and advantages of the company's high-end 1Ds, but at a street price around $1500 for the body, you get them at a fraction of the cost. Canon first showed the 10D to the public at the 2003 PMA (Photographic Marketing Association) convention. It quickly became one of the most sought-after cameras on the market. For the first six months after its release, camera stores couldn't keep it on the shelves.

Weighing less than 29 ounces, the magnesium alloy 10D body is considerably lighter and smaller than previous Canon digital SLR models. Its size and weight

are a particular advantage when shooting with several bodies, such as when shooting both film and digital, or when shooting digitally with two different lenses without having to mount and unmount them. Despite its light weight, it's a solid, well-built camera. (Later in 2003, Canon came out with the EOS 300D Digital Rebel, supplanting the 10D as the most affordable digital SLR with interchangeable lenses. However, for its capabilities, the 10D is still one of the most cost-effective cameras on the market.)

Image Sensor. The 10D's CMOS sensor can generate 6.3-megapixel files with a 3:2 aspect ratio, and a maximum resolution of 3088 × 2056 pixels. One of the reasons that Canon is able to consistently come up with superior cameras is that it's one of the only com-

Canon EOS 10D

panies that produces all three of the major components that make a difference in image quality. It produces its own CMOS chips, its own image processor, and its own extensive selection of excellent optics. A new amplifier circuit in the 10D boosts the signal-to-noise ratio for the CMOS chip, resulting in an extended sensitivity range. The standard 100 to 1600 ISO range can be boosted to 3200 through a custom setting.

Rather than incorporating a generic microprocessor in its design, like some digital camera manufacturers do, the 10D's digital imaging integrated circuit (DIGIC) processor was specifically designed for image processing. The processor that handles image processing also controls the camera functions. Its increased performance makes it possible to incorporate higher quality signal-processing algorithms than previous models. It also improves buffer performance, for faster write speeds and lower power consumption.

Shooting Speed. When shooting, the 10D responds very much like a conventional film SLR. The main difference is that with film cameras, it's possible to continue shooting until the end of the roll. With the 10D, the burst rate is more limited. It can capture a total of nine frames per burst, at a rate of three frames per second.

The rated speed matched its actual performance quite closely. Still, that's not particularly fast when compared to professional film SLRs. It is, however, considerably better than the frame rate for consumer digitals—even many higher-end models that fall into the prosumer category. It can achieve that frame rate at any image quality, including the dual RAW–JPEG file

The 10D is a professional camera with serious digital imaging capabilities at a price not much more than a consumer digital camera.

ABOVE—With a stopped-down lens, the depth of field that can be achieved with the 10D is very good.

RIGHT—The 10D integrates very effectively with Canon professional 35mm film gear. That makes it possible to limit the amount of equipment that has to be lugged around when both digital and film originals are required.

format. When saving in the dual file format, the camera writes both the RAW image data and a separate JPEG proxy of the image in one file. A large JPEG file with minimal compression is 2.4MB in size, while a RAW image file with an embedded large JPEG file is 8MB in size.

When in the single shot mode, it's possible to shoot nine frames in about six or seven seconds. Then, once the buffer has been filled, operations become sluggish. At that point, the frame rate tends to drop to an average of about one frame per two or three seconds, as images are rolled off the buffer and onto the removable media. For best performance, shoot a short burst and wait for the data to be written to the card

and then fire again. The frame rate drops even more when the pop-up flash is active, which would be the case with just about any camera using built-in flash.

Exposure Settings. Exposure options range from totally automatic to totally manual operations. Exposure modes include program AE, shutter-priority AE, aperture-priority AE, and a depth-of-field AE. Like some consumer digitals, the 10D also has a set of specialty modes with options for taking macro and night shots, as well as shooting landscape, portrait, and

sports. Each option changes all the camera's settings to optimize it for that type of photography.

Focusing. Of course, both auto and manual focusing are available. In the autofocus (AF) mode, it's possible to select AF (a one-shot focus for individual images), one-shot AF automatic with AI switching, and AI-servo AF for tracking moving subjects. Focusing is handled, as with all higher-end EOS cameras, through individual focusing points in the viewfinder. The 10D seemed a little faster in focusing than previous Canon digital bodies such as the D60. It has seven individual points, which turn from black to red when elements within the frame come into focus. It's possible to select the individual focusing points or to let the camera handle the process automatically. When focusing is complete, a focus confirmation light goes on in the viewfinder.

Metering. For metering, the aperture and shutter speeds are read and displayed on the data LCD. Half-

With the 1.7× conversion factor, a conventional 400mm lens has the coverage of a 680mm on the 10D. That increases the telephoto range but reduces wide-angle shooting capabilities.

The low-contrast characteristics of the 10D's CMOS sensor makes it easier to shoot high-contrast subjects, such as a combination of sunshine and heavy shade.

pressing the shutter release button provides a precise exposure reading. The metering modes include evaluative, partial, and center-weighted averaging.

White Balance. There are six preset white-balance modes, including a new shade white-balance setting not available on previous Canon digital SLRs. Manual white-balance can be set from 2800 to 10,000K, in 100K increments. White-balance bracketing is available in ±3 steps, in single-step increments. That increases the chances of coming up with images that provide the most accurate color renditions possible.

LCDs. There are two LCDs on the body: a very readable monochrome data display on the top and a color review LCD on the back that's also easy to view when images are displayed. The menu options that are displayed on the LCD are relatively readable, but they are on the small side.

An intelligent orientation sensor detects the shooting orientation of the camera and displays images cor-

rectly, not only when they're being reviewed on the LCD, but also when they are transferred to a computer and viewed in one of Canon's imaging modules that supports image orientation, such as File Viewer.

Another nice feature during image preview is the ability to zoom in up to 10× on the frame displayed on the LCD. That makes it possible to ensure that the expression on a person or the detail in a scene is precisely what you wanted to get. When reviewing stored images, the jump button moves the preview 10 images forward.

Menu Options. For controls, there are five buttons on the left side of the LCD. The top one accesses the menus. The main menu is divided into 18 sections in three groups: red, blue, and yellow.

The red menu group controls the shooting options. That includes things like image-capture quality and resolution, autoexposure and white-balance bracketing, and custom white-balance settings.

Items in the blue section control review options. That includes display, output, and print settings.

The yellow section is used to access setup options such as the date and time, file number protocol, power management, and LCD settings.

Custom function settings make it possible to set defaults according to personal preferences. The 10D lets you store three sets of personal preferences that include options for contrast, sharpness, saturation, and color tone.

On playback, all the pertinent metadata text information (exposure settings, what camera the image was taken with, etc.) is displayed by pressing the info button, below the menu button. A jump button simplifies navigating within the menu structure. The back of the camera also has the quick-control dial, which is used to step through menu options and make other shooting selections. It's activated through an on/off switch right above it. A mode dial on the top left-hand side is used to select the exposure option.

Other buttons close to the data LCD handle rapid autofocus and white-balance selection. During shooting, buttons on the top right adjust autofocus point selection and autoexposure lock, among other things. During image review, they control image preview options, including the zoom capabilities.

Viewfinder. The 10D comes equipped with an eye-level pentaprism with 95-percent horizontal and vertical coverage. Its diopter adjustment range is −3.0 to +1.0. Besides the image-framing and exposure information, the viewfinder contains quite a bit of other information, such as focus confirmation, exposure

The 10D was able to focus relatively quickly—even with potentially confusing subject matter.

With long telephoto lenses, it was possible to get in real tight.

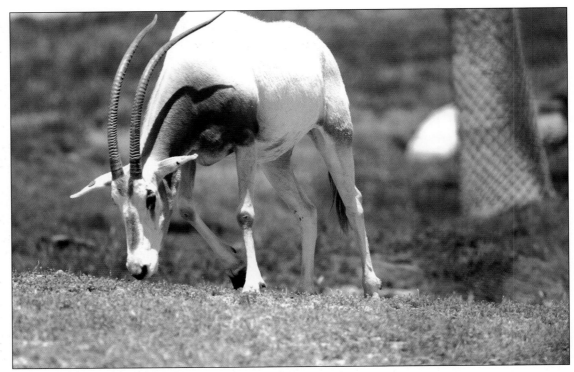

compensation amount, the number of shots remaining on the CompactFlash card, and the flash status.

Other Accessories. A separate battery grip is available as an option. The grip, with its own shutter release button, makes it much easier to shoot verticals.

Flash Functions. It's more and more unusual for professional cameras to have built-in flash units. Usually, they're not sufficient for main lighting, but they do come in handy for fill-flash and slave-flash operations. The 10D has one. Its flash has a guide number of 43 (at an ISO of 100) and supports E-TTL (electronic through the lens) autoflash, linked to all AF points. There's also a hot-shoe for external flash units. E-TTL autoflash is possible with EX series Speedlites. The flash syncs at up to $\frac{1}{200}$ second.

Lenses. The 10D takes all of Canon's EF-series lenses, providing one of the largest selections of high-quality optics on the market today. When using 35mm lenses, there's a 1.6× conversion factor.

Removable Media. EOS 10D uses CompactFlash (Type I, Type II, and Microdrive) cards to store its captured images. It supports the new 32-bit file-allocation scheme that's increasingly being used in very high capacity CF cards to store images.

Connectivity. Images can also be transferred to a computer by way of a USB cable. It ships with drivers for both Windows and Mac OS systems, and uses USB connectivity to hook up to the computers.

Battery. The camera is powered by a proprietary 7.4-volt rechargeable battery. The charger indicates how much power a battery has by a series of sequential flashes. Charging is very quick, and a single charge lasted a full day of heavy shooting. Still, it's a good idea to carry extra batteries on extended assignments.

Software. Bundled with the 10D are Canon's ZoomBrowser EX, PhotoRecord, RAW Image Converter, PhotoStitch, and RemoteCapture. Adobe Photoshop Elements also ships with the camera.

Conclusion. The easiest way to get acquainted with the 10D is by using the *Quick Operation Guide* that ships with it. It takes you step-by-step through the process of using the camera. Whenever there are multiple options available, there's an illustrated list of choices. While the detailed information that some photographers like to have about their equipment isn't in there, the guide gets you up and shooting within a few minutes of opening the box. The other documentation for the 10D is also very good, and is loaded with a wealth of information about the camera, its functions, and its capabilities. For example, it includes a handy chart with all of the menu options broken down by category. —*RE*

◼ CANON EOS 300D DIGITAL REBEL

The Canon EOS 300D Digital Rebel is a compact digital SLR with some advanced capabilities. It has finally brought digital SLRs within the budget of most photographers. Costing about $900 for the body, it's the first true digital SLR with interchangeable lenses that is targeted at the prosumer market and affordable enough for any serious photographer, amateur or professional. Weighing only 19.7 ounces, it's easy to carry along and very comfortable to shoot with. While it has a plastic body and looks somewhat like a consumer camera, it has the feel of a professional camera. While I wouldn't take my EOS Rebel 2000 on an assignment—it just doesn't have the look and feel of a professional camera—I wouldn't have any problem taking the Digital Rebel along—as I did on a recent Malaysian excursion.

Image Sensor. Offering some of the same features and capabilities of Canon's 10D digital SLR, the Digital Rebel was designed around a Canon-manufac-

tured 6.5-megapixel, high-sensitivity, single-plate CMOS sensor. It has an effective pixel resolution of 3072 × 2048 for a 6.3-megapixel image. From the standpoint of resolution, that puts the Digital Rebel in line with many of the professional digital SLRs on the market today. There really aren't that many projects that a photographer is going to encounter that would require higher-resolution originals. The sensor was also designed for maximum sensitivity (highest ISO) and low image degradation, even when taking long exposures. With a dimension of 0.89" × 0.59", the sensor is smaller than a 35mm frame, but it has the same 3:2 aspect ratio as 35mm film.

Additionally, the Digital Rebel was designed with proprietary DIGIC image-processing technology that was specifically created by Canon for use in its EOS digital cameras. It results in very high quality images. According to the company, advanced signal-processing algorithms heighten precision and detail, smooth the gradation in highlight areas, and create vivid color

While there are some differences in the electronics, the Digital Rebel is designed around the same CMOS sensor that's in the Canon 10D.

Canon EOS 300D Digital Rebel

LEFT—The Digital Rebel is a logical choice for photographers who need high-resolution digital images but are working on a budget.

RIGHT—The autoexposure settings for the Digital Rebel were quite accurate in most shooting situations, including photos that contained both heavy shadow and sunshine highlights.

reproductions. When shooting, in general, the sensor's color fidelity was very good, even under difficult lighting conditions.

White Balance. Mixed light sources didn't present too much of a problem, attesting to the Digital Rebel's superior white-balance capabilities. As with more expensive digital SLRs, it's possible to have the Digital Rebel automatically set white balance or to set it manually. There are separate settings for daylight, shade, overcast, tungsten bulb, fluorescent light, flash, and custom. The custom white balance, which lets you set the white balance to any source, comes in handy when you are photographing under unfamiliar or unusual lighting conditions.

Responsiveness. In spite of affordability, it's relatively responsive. One thing that I had been warned

about was the camera's shutter lag. I shot a lot, and didn't really experience a consistent shutter lag. There were times, though, that the camera got confused when focusing. That was usually the case when there wasn't something precise to focus on. Once I figured out the focusing characteristics, the problem was reduced, at least somewhat.

Shooting Speed. The Rebel's shooting speed is relatively good. It's rated at 2.5 frames per second for a maximum of four frames. In the single-frame mode, it was possible to shoot about three frames every two seconds. The time between frames increased to a little over two seconds after that. At about 10 frames, shooting became even slower and somewhat irregular.

LCD. The preview/review LCD is acceptable. One handy feature is the LCD's zoom option. Unlike

ABOVE—The Digital Rebel's CMOS sensor produced sharp images with accurate color.

LEFT—Captured images tended to be on the light side with the Digital Rebel. A personal preference was to shoot in aperture- or shutter-priority mode and stop down a half stop or so.

with other digitals, which can zoom in to a 3× to 4× view when reviewing the image, the Digital Rebel lets you zoom in up to a 10× enlargement. Reviewing images at such high magnification makes it easy to see the precise details. It's possible to move from image to image without having to change the magnification level. But, at times, captured images looked better on the computer screen than they did on the Digital Rebel's LCD. I had considered erasing a couple of images when I saw them on the camera's LCD but was glad that I didn't when I later viewed them on the laptop.

Battery. One consideration that always comes up when shooting digital is the power management of the camera involved. Because of the lower-power CMOS sensor and DIGIC image processing, the Digital Rebel has very effective power management built in. The camera that was tested for this book came with only one battery. As with most digital SLRs that utilize proprietary batteries, it would have been nice to have a spare battery available, but the one battery did last most of the day. I was usually able to get between 300 and 400 shots per charge. There were a couple of times when the number was even higher. That's a lot of pictures on one charge.

Controls. The physical layout of the Digital Rebel is very logical. A set of five function buttons are positioned vertically, next to the color-image LCD and the monochrome LCD that is stacked on top of it. Navigation buttons are on the other side of the LCDs. A dial on top is used to select the shooting mode, while a wheel next to the shutter release changes function, depending upon the camera status and shooting modes.

The menu structure is simple. There are four primary menus. The first determines shooting values such as image quality, autoexposure settings, and white balance. The second is the output menu, with options to protect and print images, and the ability to rotate the image when displayed. The last two are operational menus that do things like set the time and date and format the CompactFlash cards. There is also a special setting to clean the image sensor.

The Digital Rebel offers a complete range of exposure, metering, and focusing controls. Full shiftable program AE, aperture priority, shutter priority, auto depth-of-field AE, and manual shooting modes are available. Autoexposure lock is available to prioritize the exposure based on a specific subject or element within the composition. Exposure compensation is available up to ±2 stops, as is autoexposure bracketing. A depth-of-field preview button lets you see just what range within a composition will be in focus.

When shooting in the autoexposure mode, the results were relatively good. There were times, howev-

While there is a 1.7× conversion factor when using 35 mm lenses on the Digital Rebel, it's still possible to come up with wide-angle photos. The 18–55mm lens that comes standard with the Rebel provides the 35mm equivalent of around 28–90mm.

ABOVE AND LEFT—The Digital Rebel is a good choice for photographers who are on the go. It's not quite as intimidating as some of the other digital SLRs, making it well suited for photographing people when traveling.

FACING PAGE—In spite of its plastic body, it's a sturdy and well-balanced camera with broad capabilities.

er, when images were too light. When shooting manually, I tended to shoot at the metered reading for the aperture and set the shutter speed somewhat faster.

Special settings for different types of photography, such as landscapes, close-ups, and night portraits, are also available. They set the camera's exposure options for optimum photographs for the different types of photography. Such settings are usually only found in

consumer cameras, targeting photographers who may not understand what camera settings are required for different types of shooting. That makes the 300D a good choice for photographers who are just getting into photography and would like to try different types of shooting, but aren't quite confident enough about their capabilities to experiment.

Exposure. The Digital Rebel comes equipped with a 35-zone autofocus-point-linked evaluative metering sensor. Multiple metering modes, including aperture TTL metering, evaluative metering, partial metering at center, and (in the manual mode) center-weighted averaging, are available.

The Digital Rebel is a good choice for photographers who want to go beyond consumer digital cameras.

Focusing. The Digital Rebel uses Canon's wide-area autofocus system. One or more of the seven focusing squares turn red when objects in the frame are in focus. Individual focusing points can be selected manually by the user, or automatically by the camera.

The camera employs one of three focusing methods to optimum image clarity. One-shot AF ensures accurate focusing for all-around, general shooting. There's also AI-servo AF for focus tracking. It tracks active subjects to predict their movement, making continuous focusing calculations as the subject moves across the frame, for accurate focusing as the action unfolds. AI focus AF switches between one-shot AF and AI-servo AF, when the focusing mechanism senses

that objects within the frame are starting and stopping. Autofocusing tended to be a little on the soft side. Manual focusing is also available. There is built-in diopter correction.

ISO. An extended ISO range of 100 to 1600 makes it possible to shoot in relatively low light situations. When using the built-in flash, the ISO setting is automatically set to 400 ISO in full auto, close-up, and night-portrait modes. In the portrait mode, it is set to 100 ISO.

Shutter Speed. The shutter speed extends from 30 seconds all the way to $\frac{1}{4000}$ second. A bulb setting is also available. It flash syncs up to $\frac{1}{200}$ second. A built-in flash is available, but it doesn't have a PC-cord con-

nector. A slave or radio device attached to the hot shoe can be used to trip professional flash units.

Capture Considerations. The camera can write captured images to either RAW or JPEG files. The RAW format is becoming increasingly important, and common, for professional applications. To increase preview speed and functionality, the Digital Rebel can simultaneously write both a RAW file and a JPEG file to the removable media. When shooting that way, you have the optimum quality with the RAW digital data, while retaining the speed for image review and electronic transfer that JPEG provides.

Removable Media. Once captured, images are stored on CompactFlash cards. The camera can take either Type I or Type II CF cards, including the miniature Microdrives.

Lenses. The camera takes all of Canon's EOS EF lenses, including the newly released EF-S series lenses, which were specifically designed for the Digital Rebel line. For shooting versatility, there are more than 50 different EF lenses that can be used with the 300D Digital Rebel, all the way from very wide-angle to extended telephoto, as well as fisheye, macro, and perspective correction (PC) lenses. It ships with an EFS 18–55mm lens, which is roughly the coverage of 28mm–90mm on a 35mm camera when the 1.6× conversion factor is applied.

Conclusion. The Canon Digital Rebel 300D is a solid piece of equipment that would serve most photographers very well. It's particularly well suited for serious amateurs who are interested in going beyond the capabilities of a consumer digital but don't have the budget for higher-end professional models, and for some professional photographers who occasionally need to shoot digitally in situations where quality is a consideration, but speed isn't. —*R.E.*

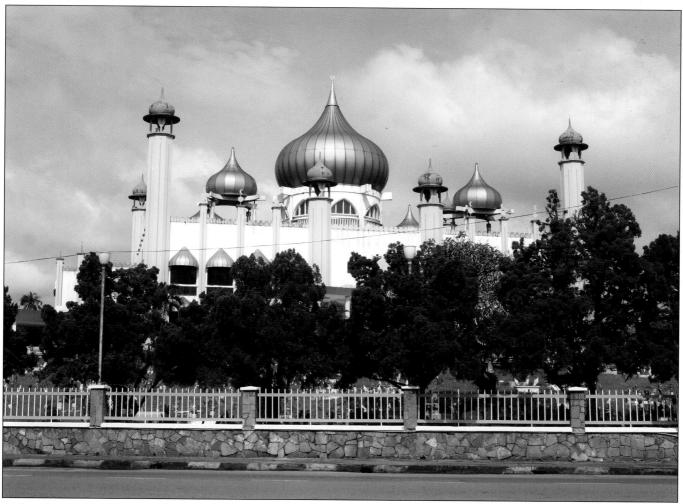

It takes all of the EOS EF lenses, including the newly released EF-S series lenses, which were specifically designed for it.

3. NIKON DIGITAL SLRs

Nikon camera bodies have been the basic building blocks of the digital SLR line since Eastman Kodak's introduction of the $30,000, 1.3-megapixel Nikon F3–based DCS-100 at Photokina in 1990. Kodak used the Nikon Pronea body for its DCS 315 and DCS 330 cameras, and the Nikon N90 line for its DCS 420s and 460s. Nikon F5s formed the basis for Kodak's DCS 620, 620x, 660, 720x, and 760 digital SLRs, all discontinued now. Kodak has retained its Nikon ties with its current digital SLRs, the DCS Pro 14n and the recently introduced Pro/n, using a magnesium alloy–enhanced camera body based on the Nikon N80.

The first digital SLR to wear the Nikon name on the pentaprism, the D1, was introduced in 1999. Now discontinued, the D1 was quickly adopted by photojournalists and professional photographers who appreciated its light weight compared to the F5-based Kodak digital cameras, its rugged magnesium alloy construction, and the quality of its images. The similarity to their Nikon film-based cameras and the fact that they could use most (if not all) of their existing Nikon lenses were major contributing factors as well.

The current digital SLR line from Nikon includes a range of cameras that are targeted, in terms of their features and prices, to professional photographers. These include the D1x and D1h introduced in 2001, and the D2h introduced in 2003. The D100, introduced in 2002, represents Nikon's successful effort to package a high-quality imaging sensor into a less expensive, lighter-weight body for advanced amateurs and professionals. As we were writing this book, Nikon announced a new consumer digital SLR body, called the D70, to be available in 2004 with a suggested price of $999.

One of the factors that has drawn professional photographers to Nikon cameras is the quality of Nikkor lenses. Not only is the Nikkor lens line vast, with focal lengths from fisheye to super-telephoto, but

Most of the current family of Nikon digital SLRs. Left to right are the D100, D1x, and the D2h. Missing is the D1h.

At an ISO setting of 800, the D1x gives better image quality than slide film for low-light concert photos. Shooting in RAW format offers a wide range of color-balance and exposure options when processing the original capture in Nikon Capture software.

Nikon has also adopted the philosophy of designing new camera models to be compatible with legacy Nikkor lenses. This is also true with Nikon's digital cameras. Nearly all Nikkors from the AI-modified manual-focus lenses to the latest vibration-reducing, auto-focus, internal-focusing, silent-wave models are compatible with Nikon digital SLRs.

However, lenses optimized for the 35mm film frame are not necessarily the best solution for the reduced-size CCD sensors in Nikon digital SLRs. This is particularly true for wide-angle and high-ratio zoom lenses whose design is the most complex and involves the most compromises. Therefore, Nikon has introduced a line of DX lenses optimized for digital SLRs that accept F-mount lenses. Smaller and lighter in weight than lenses optimized for film, Nikon's DX lenses represent an ideal solution for photographers who will only be shooting with compatible digital SLR cameras.

◼ THE NIKON D1x

The D1x remains Nikon's top-of-the-line, general-purpose digital SLR for professionals, even though the model is now several years old and housed in the same body as the even older D1 (as is the D1H). The D1x is clearly meeting the needs of the professional market in terms of image quality, reliability, and ruggedness.

The D1 series is derived from the Nikon F100 with a body made of rugged magnesium alloy. Weighing in at 40 ounces without its proprietary

Nikon D1x

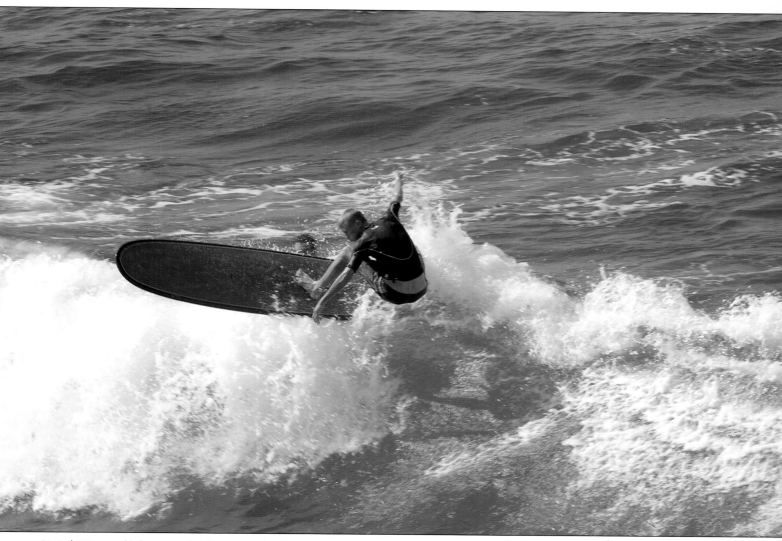

Digital SLRs are ideal cameras for shooting with telephoto lenses. Because the image sensor in the D1x is smaller than a 35mm frame, a 200mm lens with a 1.4× tele-extender becomes the equivalent of a 420mm lens, great for photographing surfers from a distance.

NiMH rechargeable battery or lens, the D1x has the substantial feel of a professional camera.

Image Sensor. The imaging CCD in the D1x is the same physical size as that found in the D1, 23.7mm × 15.6mm, giving the lens a 1.5× focal-length multiplication factor. However, where the D1's array was made up of square 11.9-micron elements, the array in the D1x consists of rectangular elements of the same vertical height (11.9 microns), but about half the width (5.9 microns). This arrangement results in a 5.33 million effective pixel CCD arranged in a 4024 × 1324 pixel sensor array. Information from this array is processed in the camera to an equivalent resolution of 3008 × 1960 pixels (large setting) or 2000 × 1312 pixels (medium setting).

With Nikon Capture or third-party software, it is possible to process the D1x's RAW file to higher pixel resolutions. For example, C1 digital SLR software from Phase One can process the RAW sensor data to a resolution of 4020 × 2632 pixels. The RAW plug-in for Photoshop 7 or the RAW file conversion in Photoshop CS will process the data to even higher resolutions. Processing the raw sensor data with the proprietary algorithms developed by Nikon and some third-party vendors results in a much higher quality output than increasing the resolution of a TIFF or other bit-mapped file. This step is neither interpolation nor extrapolation of resolution since there are no "pixels" until the sensor data is processed and stored as such, as mentioned earlier in this book. Nikon Capture soft-

ABOVE AND FACING PAGE—The D1x provides 15 different bracketing combinations to ensure an accurate exposure in a wide range of conditions, including this −⅓, normal, +⅓ EV sequence.

ware, in fact, deems the higher resolution "100 percent" resolution.

In-camera processing is accomplished at high speed with a combination of hardware and software. Early versions of the D1x captured images at a rate of three frames per second and could store nine consecutive TIFF or JPEG files, or six RAW files, in the on-board buffer. These early models could be sent to Nikon for a $200 buffer upgrade allowing 21 TIFF (or JPEG) or 15 RAW files to be shot in a burst at three frames per second. This larger buffer is now standard in the D1x.

Layout. The D1x provides a logical layout of camera controls that will be familiar to anyone who has handled a Nikon F5 or F100 camera. A LCD panel on the top of the camera displays camera status informa-

tion. Four exposure modes are provided, including auto-multi program (with flexible program), shutter-priority auto, aperture-priority auto, and manual. Pressing the mode button on the top right of the camera and turning the main command dial on the upper right of the camera back selects them. An exposure-compensation button providing ±5 EV compensation in ⅓-EV steps sits next to the mode button. An auto-exposure/autofocus lock button on the back of the camera locks these functions as long as it is depressed in single-frame and continuous shooting modes.

In all exposure modes, shutter speeds from 30 seconds to $\frac{1}{16,000}$ second and Bulb are provided by a combination of mechanical and charge-coupled electronic shutters. Flash synchronization is possible up to $\frac{1}{500}$ second.

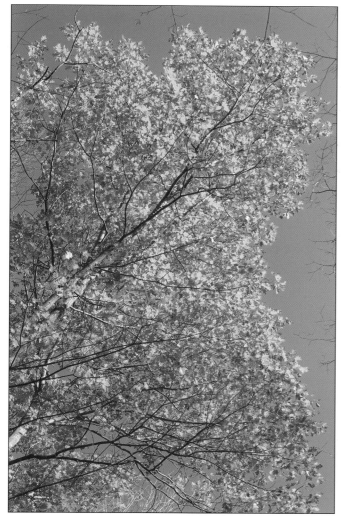

Camera Controls. A dial on the left of the camera top provides control over bracketing, ISO settings, and flash mode. Thirty options in ⅓-, ½-, or full-EV steps are available for bracketing in all four exposure modes by using the custom settings. ISO equivalents can be set in ⅓-, ½-, or full-EV steps (depending on the custom setting) from 125 to 800. The custom menu allows the ISO to be boosted to 1600 or 3200, but with some increase in noise. In reality, these boosted ISOs are very functional, and the images captured reproduce far better than those taken with film at these ISOs.

Depending on the optional flash unit that is attached, five flash-sync modes are available: front-curtain, rear-curtain, slow shutter-speed sync, red-eye reduction, and red-eye reduction with slow sync.

Surrounding this dial is a locking mode dial. This allows the selection of single-frame or continuous shooting, playback, self-timer operation, and PC (Windows or Mac) operation.

Metering. Metering options (spot, center-weighted, and 3-D matrix) are selected by rotating the locking dial to the right of the pentaprism. Spot metering uses the information centered on the selected focus area (among the five available on the interchangeable focusing screen). Center-weighted metering measures light over the entire frame but gives greatest weight to a circular area in the center of the screen. For most situations, but particularly when there are large areas of light or dark colors in the frame, 3-D color matrix metering yields the best results with the D1x, as it tends to bias away from overexposure.

Focusing and Flash. The focus modes (single-servo autofocus, continuous-servo autofocus, and manual focus) are selected using a switch on the front of the D1x. In single-servo autofocus, the shutter will not release unless the subject is in focus in the currently-selected focus area. This mode also locks the focus once it is achieved, as long as the shutter release is halfway down. In continuous-servo mode, the camera focuses continuously while the release is pressed halfway, tracking moving subjects. The focus is not locked, so the shutter will operate even if the subject is not in focus. Autofocus is quick and accurate, even in dimly-lit, low-contrast situations.

The manual setting is designed for use with non-autofocus Nikkors, or for situations where autofocus will not operate. Many newer Nikkor autofocus lenses allow manual focusing along with autofocus without the need to adjust switches on the lens or camera, so this setting would be used primarily with non-autofocus lenses or in close-up and macro photography.

Using the hot shoe atop the pentaprism, the D1x accepts many Nikon electronic flash units, but the latest flash models ensure the greatest compatibility with the full range of camera modes. There is no pop-up flash on the D1x, but a PC-sync terminal is provided in the customary position on the front of the camera for connecting studio flash units. Just below it is Nikon's standard terminal for connecting remote control devices.

Menu Options. While the camera body provides buttons and switches to operate the essential camera

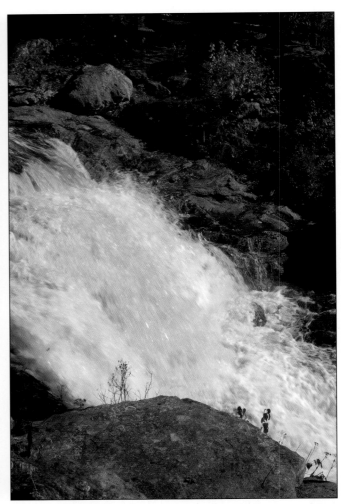

In manual mode, the D1x provides shutter speeds from ¹⁄₁₆,₀₀₀ second to 30 seconds, plus bulb. On the left is a capture made at the ¹⁄₁₆,₀₀₀-second shutter speed; on the right is the same scene at ¹⁄₆₀ second.

functions, many selections can also be made from menus displayed on the 2-inch, high-resolution LCD on the camera back, which also displays images for review and menus for digital functions.

It would take an entire book to detail all of the options available in the menu structure of the D1x. In fact, the user's manual is a 223-page book that clearly and in excellent detail explains all of the possible selections. For most users, this will be more of a reference manual, since the camera menus are so clearly and logically organized into sections (shooting, playback, custom (CSM), and setup). These sections are color coded and the options display clearly on the screen, even in bright ambient light.

Flipping down a magnetically latched door beneath the LCD image display screen and pressing the menu button accesses the menu system. Quick-access

buttons for changing white balance, protecting images from erasure, thumbnail viewing, and a programmable function button are also located here. At first it seemed like it would be a bother to keep opening and closing this door. But it turned out that with the type of shooting most people would do with the D1x, you open it once to make the appropriate settings at the beginning of a session, then close it, preventing you from accidentally pressing the buttons and changing the settings.

The shooting menu covers selection of image quality, white balance, ISO, and other functions. Three JPEG compression ratios are available, along with a high-quality setting. High offers the additional options of saving the capture as a RAW file (compressed or uncompressed), RGB TIFF, and YCbCr TIFF (an efficient three-channel TIFF format that occupies less file space than an RGB TIFF but requires proprietary soft-

ware for viewing). Captures can be saved in either sRGB or Adobe RGB color spaces.

Eight white-balance options are available, including the ability to create and store custom white balances. In each of these options, other than custom, the white balance can be fine-tuned over a narrow range. For images captured in RAW format, white-balance settings (and many other settings) can be more accurately adjusted in post-processing.

The playback menu is used to select card-format, image-deletion, image-protection, slide-show, and display-mode options. Images can be displayed on the LCD as images only, images with composite histogram, images with flashing highlight areas, and images with both histogram and flashing highlight areas. Even when the ambient light makes it difficult to see the image, it is possible to see the histogram clearly. Only one zoom level is available, showing about $\frac{1}{20}$ of the image, though this can be panned anywhere in the image.

Thirty-six custom settings allow photographers to personalize the D1x for their particular shooting style. Four "banks" are available for storing sets of custom settings. The settings for shooting wedding candids could be stored in one bank, wedding group shots in another, studio portraits in another, etc. Then, in the appropriate shooting situation, the entire group of settings could be called up all at one time by simply selecting that "bank" from the custom menu. The manual does come in handy in understanding all of the possibilities in these 36 custom options.

Formatting the storage card can be done by pressing two clearly marked buttons on the camera, or by selecting "format" in the setup menu. This menu is also used to choose the language used to display the menus, to select the video standard to be used to display images on a television or VCR, to set the date, to adjust LCD monitor brightness, to specify how long the monitor will remain on when no operations are performed, and to adjust settings for connection of a GPS device.

While all of these choices may seem overwhelming, in reality, most photographers won't even need to bother with them till the day when they think, "I wish I could do 'X' with this camera." A quick run through the menus, or some time with the manual, and more than likely, there will be a way to make the wish come true.

Removable Media. Behind a latched door on the back of the D1x, one slot is provided for file storage on a CompactFlash Type I or Type II card, or a Microdrive.

Software. Connection to the computer is only available through an IEEE 1394 (FireWire) interface. Included as part of the D1x set is Nikon View software for Windows operating systems (Windows 98 SE to Windows XP) and Macintosh operating systems (OS 9.0 to OS 10.1.2 or later). The Nikon View software is only used to locate and then view image captures, including RAW captures. Changes or corrections to the file, or conversion of the RAW capture to TIFF or JPEG, is done by clicking on the edit icon in Nikon View, which opens the Nikon Editor software. This program provides only minimum control over adjustments and will not save the adjustments made to RAW files. Nikon View loads a plug-in into Photoshop, so it is possible to open captures in Photoshop directly from Nikon View.

For complete control over RAW captures, it is necessary to purchase the optional Nikon Capture software. This is a truly full-featured program allowing total control over RAW captures. It also includes features that will remove the distortion from captures taken with the 10mm DX fisheye lens. It also automatically removes dust specks without softening the image. While some third-party software products offer a more efficient workflow for dealing with Nikon RAW images, none offer the full feature set of Nikon Capture software.

Nikon Capture is also needed in order to shoot directly from the D1x to the computer. Like all software that performs this function, there is a fairly steep learning curve for most photographers, but Nikon Capture provides all the necessary controls to turn the D1x into a single-shot digital studio camera capable of creating high-quality 67MB, 48-bit image files.

Conclusion. I love my D1x and feel that it is the best digital SLR camera for my work. Still, having worked with all of the Nikon-lens digital SLRs in this book, it is not without its faults. Chief among these is

its battery life, which is far too short for my taste. Even when I consciously work in "battery-conserving mode" (no automatic previews after capture, minimum checking of images on the LCD, not holding the shutter release partway down any longer than absolutely necessary to focus, turning the camera off when not actually shooting, etc., etc.), I am consistently disappointed in the number of captures I can make before I need to change batteries.

The other thing that bugs me is the inability, in some circumstances, to view the last image captured. For example, if you make a capture without viewing it, but instead call up the menus to change a setting, there is no way to get back to view the image. In fact, anytime you turn on the monitor, it displays the last thing that was displayed on the menu. In order to view the last image taken, you have to make another capture, view it, then use the four-button dial on the camera back to navigate back to the image you want to see. According to the manual, it shouldn't work like this, but it does with my D1x.

These issues aside, the D1x can handle any but the most demanding high-speed sports or photojournalistic action. Its portrait grip and vertical release button make switching from horizontal to vertical shooting comfortable and well balanced, even though the D1x does not automatically detect vertical shots and orient them as such in Nikon View software. The price of the Nikon D1x has been dropping slowly to its present level of just under $4000, and previously optional items, like the larger buffer, have been added to make the camera an increasingly better value. Just be sure to purchase a spare battery and Nikon Capture software to get the most out of the D1x. —S.S.

■ THE NIKON D1H

Despite the introduction of the Nikon D2H, the D1H remains available with a street price of about $3000. The "H" designation in the D1 series stands for "high-speed" capture. The D1H is capable of capturing five frames per second to a maximum of 40 captures in JPEG or TIFF mode, or 26 consecutive captures in RAW mode. Custom settings allow the user to set the burst rate (from 1–5 frames per second) and the burst depth (1–40 frames).

The imaging sensor is an updated version of that on the D1, with a 2.66 million effective pixel CCD, arranged in a 2012 × 1324 sensor array. This array is processed to a 2000 × 1312-pixel image. The sensor size is 23.7mm × 15.6 mm, so there is a 1.5× focal-length multiplication factor. That will be welcomed by most sports photographers, since it turns their 300mm lenses into a 450mm ones.

Other than these differences, and an ISO range of 200–1600 (with custom settings allowing these to be boosted to 3200 and 6400), the D1H has similar specs to the D1x. At the time of its introduction, it was the only choice available for photographers who needed a high capture rate. Then Canon captured bragging rights with the 4-megapixel, eight-frame-per-second EOS-1D. Nikon countered and raised the bar with the D2H. —S.S.

■ THE NIKON D2H

In mid-2003 Nikon introduced the D2H, a professional digital SLR designed primarily for photojournalists and sports/action photographers, but also giving clues into the likely direction Nikon intends to go with other professional digital SLRs in the future.

Image Sensor. The D2H incorporates a new image sensor developed by Nikon that in many ways acts as a hybrid CCD/CMOS device. Incorporating square sensor elements of 9.4 × 9.4 microns, the sensor size is 23.3mm × 15.5mm, giving a 1.5× lens focal length multiplication factor. Nikon is calling this sensor size "DX format" in keeping with its newly developed line of digital camera lenses designated "DX."

Nikon calls the 4.1 effective megapixel (2484 × 1636) sensor a "JFET imaging sensor LBCAST." JFET stands for "junction field effect transistor," the type of transistor commonly used in high-end audio amplifiers because of its low noise and fast switching characteristics. LBCAST is an acronym for "lateral buried charge accumulator and sensing transistor." This sensor contains a light-collecting photodiode in each element in a design similar to, but different than,

Nikon D2H

CCDs. The analog signal from the sensor elements is converted to a digital signal and amplified (by the JFETs) in a manner analogous to the on-chip processing of CMOS sensors. The digital signal is read from the chip two colors at a time, achieving higher speeds than other designs.

Nikon's JFET imaging sensor LBCAST design, in theory, offers lower noise and increased dynamic range over CMOS sensors and faster operation with lower power consumption than CCDs. While I was unable to confirm the lower noise in comparison with a CMOS-based digital SLR, the D2H images *are* less noisy than those of the D1X—particularly at ISOs of 3200 and 6400. Power consumption is much improved, exhibited in far greater battery life per charge. Whether this is due to the sensor design or the new compact 11.1-volt lithium-ion rechargeable battery is unclear, but it is certainly welcome.

Files can be saved in a wide variety of ways. Two image sizes are available, 2464 × 1632 pixels (large)

First and foremost, the Nikon D2H was designed to capture speed. It's really the first digital SLR that can compete with film cameras when shooting sports and action.

With its large internal buffer and fast write speeds, the D2H can capture images at a rate of eight frames per second—up to as many as 40 frames.

and 1840 × 1224 pixels (medium). These can be saved as RGB–TIFF files, JPEG files in three different compression ratios, or either uncompressed or compressed RAW files. Additionally, either type of RAW file can be saved at the same time as any of the three types of JPEG files. The color space is selectable between two modes of sRGB, one optimized for portraits and one for landscapes, and Adobe RGB.

Nikon has not strayed from the "classic" design of the original D1 with the D2H. At 40 ounces without

battery, the weight and feel of the magnesium-alloy body are identical to that of the D1x—rock solid and built to take the kind of punishment photojournalists and sports/action photographers put their cameras through.

Responsiveness and Shooting Speed. For photographers in what Nikon sees as the D2H target market, it's all about capturing the peak of action at a decent level of quality and moving those images on-line as quickly as possible. These needs have been addressed in the D2H.

Unlike many other digital SLRs, the D2H is ready to shoot the instant the camera is switched on. The camera is designed such that it does not need to cycle through a "boot" cycle at startup. In addition, the lag between pressing the shutter release and the capture being made is only 37 milliseconds, comparable to the Nikon F5 film camera and about two-thirds that of the

D1x. By changing the mirror mechanism, the blackout time in the viewfinder between captures is less than the F5—80 milliseconds, according to Nikon.

In the continuous high shooting mode, the maximum capture rate of the D2H is eight frames per second—as long as the shutter speed is $\frac{1}{250}$ second or less. It is possible to select slower rates through the custom-setting menu. A maximum burst of 40 JPEG, 35 TIFF, or 25 RAW captures can be made before the buffer is full. Again, this can be lowered through a custom setting.

Focusing. All of the shooting speed built into the D2H would be of little value if its autofocus system couldn't keep up. To ensure that it could, Nikon completely redesigned the autofocus system used in the D2H. Where the D1 family utilized five focusing areas, the D2H autofocus system consists of 11 autofocus sensors. Nine of these are laid out consistently with the rule-of-thirds composition grid, with two additional sensors placed at the longer end of the frame. To control these added focusing sensors, what was a four-position dial on the D1 camera back is now an eight-position dial on the D2H. (This change also facilitates moving diagonally through the image when reviewing it zoomed-up on the display.) Using custom settings, the user can combine sensors into groups to further widen the focus coverage. Dynamic autofocus has also been improved, as has the ability to focus at low light levels. Autofocus on the D2H is easily the fastest, most accurate of any Nikon camera ever built.

Camera Controls. Camera controls on the D2H follow the layout of the D1 family. An LCD panel on the top of the camera displays camera status information. Four exposure modes are provided, including auto-multi program (with flexible program), shutter-priority auto, aperture-priority auto, and manual.

Shooting at $\frac{1}{1000}$ second, it was possible to stop action in midair.

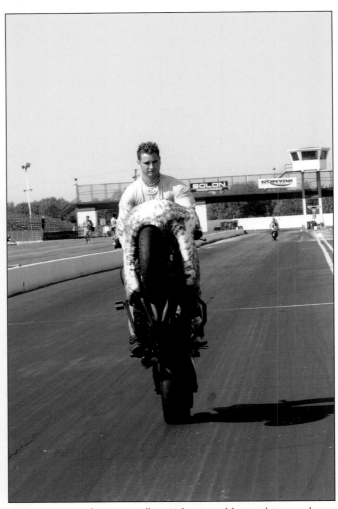

ABOVE AND FACING PAGE—It's very responsive in both metering and focusing. Focus tracking is excellent. When a problem with image sharpness does crop up, it's more likely a problem of the photographer not being able to track the action effectively than the camera not being able to respond.

Pressing the mode button (triangle-shaped on the D2H) on the top right of the camera and turning the main command dial on the upper right of the camera back selects these modes. An exposure compensation button (also triangular) providing ±5 EV worth of compensation in ⅓-, ½-, or full-EV steps sits next to the mode button. An autoexposure/autofocus lock button on the back of the camera locks these functions for as long as it is depressed in the single-frame and continuous shooting modes.

In all exposure modes, the electronically-controlled, vertical-travel focal-plane shutter provides shutter speeds from 30 seconds to ⅟₈₀₀₀ second in ⅓-, ½-, or full-EV steps. There is also a Bulb setting. Flash synchronization is possible with all flash units up to ⅟₂₅₀ second.

ISO equivalents can be set in ⅓-, ½-, or full-EV steps, depending on the custom setting, from 200 to 1600. Custom settings allow the ISO to be boosted higher, to 3200 or 6400.

Other camera functions are similar to those on the D1x, although there are even more ways to customize them for specific situations or shooting styles. Four "banks" are provided for storing these custom settings for quick recall.

Lenses and Flash. The D2H accepts the same wide range of Nikkor lenses and accessories as the D1 family, including the remote-control devices. A custom setting allows the user to input data for older, non-CPU lenses to gain access to camera functions that would normally be only available to newer CPU lenses, for example color-matrix metering and balanced fill

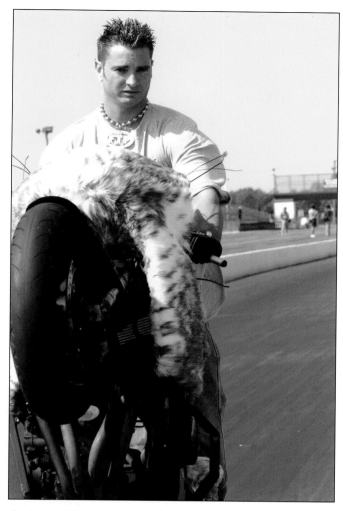

flash. (CPU lenses feature a built-in processor to communicate with the camera body.)

Newly designed for the D2H is Nikon's latest electronic flash, the SB-800. A host of new features are available, including wireless flash control with the on-camera SB-800 controlling up to three groups of SB-800 flash units, with any number of units per group. The SB-800 will also sync with the D2H up to its maximum $\frac{1}{8000}$-second shutter speed. A PC-sync terminal is also provided in the customary position on the front of the camera for connecting studio flash units.

Layout and Functions. Camera settings are displayed in the top control-panel LCD and below the image in the viewfinder. Digital functions are displayed in the rear control-panel LCD and also in the viewfinder of the D2H to the right of the image.

While the top plate and front of the D2H bears a strong resemblance to the D1x, the back (where the digital function controls are located) looks more like the Nikon D100. This is a good thing, because the previously tiny buttons located behind a magnetically latched door on the D1x are now larger and exposed for quick access—more appropriate to the faster-shooting pace of D2H users.

The D2H back is dominated by a large 2.5-inch color LCD display with 211,000-pixel resolution positioned directly below the viewfinder eyepiece. Since this is larger and higher in resolution than the screen on the D1-series cameras, it makes menu selection as well as image playback a much more pleasurable experience. The location is much improved over the D1-series cameras. No longer will right-eyed photographers be pressing their nose against the LCD.

To the left of the LCD is a vertical row of four buttons. Topmost is the menu button for calling up and canceling the menu display. Below it is the thumbnail button, which allows the display of four or nine images per screen. The third button down is the protect button, used to mark images to prevent erasure or to mark for download. At the bottom is the enter button, used to accept menu selections. This button also functions as the zoom button, in conjunction with the main command dial, during playback. Below these is a tiny speaker.

The menus of the D2H are organized into four major sections: shooting, playback, custom (CSM), and setup. This is like the D1-series menus, but with even more selections. There are so many custom settings, for example, that they are organized into six color-coded groups: autofocus, metering/exposure, timers/AE and AF lock, shooting/display, bracketing/flash, and controls.

Digital function settings are shown on the rear control-panel LCD, to the right of the speaker and directly below the image LCD. Quick-access buttons for changing the ISO setting, image quality/size, and white balance are located below the rear control-panel LCD.

White Balance. The D2H offers even more white-balance settings than the D1. Along with auto, incandescent, fluorescent, direct sunlight, flash, cloudy, shade, and preset, the user can also set a color temperature in the range of 2500K to 10,000K. For settings other than preset, and where the user selects the color

temperature, it is possible to fine-tune the white balance in 10-mired increments through a small range.

The D2H also incorporates a new automatic white-balance system. On the front of the pentaprism, above the Nikon name, is a new external ambient light sensor. Information from it is incorporated with information from the 1005-pixel metering CCD and from the sensor itself to determine an optimum balance when white balance is set to auto. For photographers shooting and uploading JPEGs for immediate transmission, this should save someone some time fiddling with color balance. Most photographers using this camera, however, would no more be using the auto-white-balance than they would the program exposure mode. So this system will likely not find much practical use unless it offered consistently perfect white balance, which, in the limited time I had with the D2H, was not the case.

Color Modes. To suit different photographers' workflows, three color modes are available. The default is mode I, an sRGB workspace suited for portrait shots that will be used "as is" or printed without adjustments. Mode II is Adobe RGB and embeds an ICC profile in the image information that applications supporting color management can read. Mode III is another sRGB workspace suited for landscape or nature photos that will be used "as is" or printed without corrections.

The options possible for controlling the camera and the digital functions are truly mind-boggling. Fortunately, the well-organized and clearly written descriptions in the manual come in handy for sorting out the best options for any situation. And once you figure out a group of settings that work for you, they can be stored in one of the four "banks" for instant recall when needed in the future.

Connectivity. The D2H connects to computers through a USB 2.0 interface that is backward compatible, though at a considerably reduced speed, with USB 1.1. Since many older Windows and Macs (including G4s) have a fast IEEE 1394 port but only USB 1.1 interfaces, this seems a questionable choice. As time passes and users upgrade computers, this will be less of an issue.

Moving captures from the D2H to a laptop computer or even directly to a server on an intranet can also

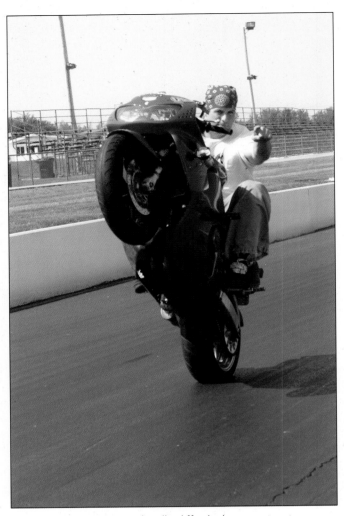

ABOVE—The camera can handle difficult shooting situations, even when right on top of the action.

FACING PAGE—The images captured with the D2H's unique sensor were somewhat higher contrast than those captured with other digital SLRs.

be done by means of an optional wireless transmitter that attaches to the bottom of the camera. Connection is made through IEEE 802.11b WiFi, not the fastest possible connection, but adequate for the JPEG files that will most likely be sent. Captures can be transmitted and stored simultaneously.

Removable Media. Image files are stored in the camera on a CompactFlash (Type I or II) or Microdrive card located behind a latched cover. Space is only provided for one card. In-camera formatting supports media with greater than 2GB capacity.

Using the fastest CompactFlash cards, for instance the 40× Lexar cards with write acceleration (which *is*

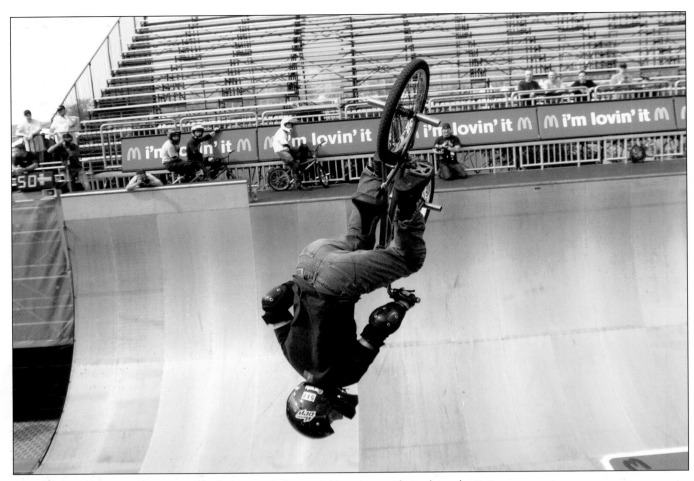

The D2H was able to stop action at precisely the intended moment. There was no shutter lag or hesitation.

supported in the D2H), will ensure the fastest possible operation.

Software. Included as part of the D2H set is Nikon View software for Windows operating systems (Windows 98 SE to Windows XP) and Macintosh operating systems (OS 9.0 to OS 10.1.2 or later). Only the latest version of Nikon View will read the D2H RAW file format, but this can always be downloaded from the Nikon web site.

The Nikon View software is only used to navigate to and then view image captures, including RAW captures. It will correctly orient vertical images from the D2H, provided they are taken using the vertical release button at the base of the camera grip, eliminating the need to rotate them manually. Changes or corrections to the file, or conversion of the RAW capture to TIFF or JPEG are done by clicking on the edit icon in Nikon View, which opens Nikon Editor software. This program provides only minimum control over adjust-

ments, and will not save the adjustments made to RAW files. Nikon View loads a plug-in into Photoshop, making it possible to open RAW captures in Photoshop directly from Nikon View.

It is necessary to purchase the optional Nikon Capture software for complete control over RAW captures. Only the latest version, Nikon Capture 4, will open the D2H RAW file. Nikon Capture 4 is also needed in order to shoot directly from the D2H to the computer, but not to receive images from the D2H through the optional IEEE 802.11b interface.

Conclusion. Even given the new sensor, the fast operation, the new electronic flash system, and all of the other advances in the D2H, it still comes down to whether or not you're willing to trade file size for them. For photojournalists and sports/action photographers, owning the D2H is a given—particularly since the camera is available for just over $3000, only a couple of hundred dollars more than a new D1H.

Whether or not the camera fits into your way of shooting, it is nearly impossible to find fault with the D2H. Nikon's experience with the D1 cameras, combined with their years of experience with photojournalists and sports/action photographers, is clearly displayed in the D2H.

If the D2H with its new JFET imaging sensor LBCAST is any indication of the direction Nikon is headed with its digital SLRs, then the future looks to be pretty exciting. Rivalry with arch competitor Canon and new entries from other manufacturers will continue to drive down prices and to drive up quality and handling characteristics. —S.S. (photos: R.E.)

■ THE NIKON D100

For photographers who aren't shooting heavy-duty commercial assignments but still want a professional-level digital SLR on which to mount their Nikkor lenses, Nikon makes the D100. Constructed of composite material over a metal frame, the camera bears a striking resemblance to Nikon's D80, but the similarities are only superficial. Nikon totally gutted the N80 to build the D100 (and the 14n for Kodak).

Image Sensor. The image sensor of the D100 is a CCD that measures 23.7mm × 15.6mm with 6.1 million effective pixels. The lens focal length is, therefore, approximately 1.5 times that of the 35mm film equivalent. The maximum resolution of the sensor is 3008 × 2000 pixels. A maximum-resolution capture can be saved as a 12-bit RAW file (compressed or uncompressed), an RGB–TIFF, or a JPEG in one of three compression ratios. The D100 supports two other resolutions, 2240 × 1488 (medium) and 1504 × 1000 (small) that can be recorded as TIFF or JPEG (but not RAW) files at correspondingly smaller file sizes.

Shooting Speed. At the largest file size, the D100 captures three frames per second up to a total of six frames for TIFF and JPEG formats and four frames in RAW format. This rate remains constant regardless of the file size. The images can be reviewed immediately, even while the camera is writing them to the storage card.

The D100's built-in flash and quick, simple operation makes it easy to catch fleeting moments with pets.

Nikon D100

Battery. While battery life with the lithium-ion battery provided with the camera is excellent, one accessory for the D100 that will be a must-have for many photographers is the MB-D100 Multi-Function Battery Pack. It only adds 7.4 ounces (without batteries) to the 25 ounces of the D100 (without batteries), and provides a number of welcome features. One is the weight itself, which, along with the more substantial grip, balances and stabilizes the camera with the heavier Nikkor lenses. More important is the inclusion of a portrait-orientation grip with a lockable vertical release and a subcommand dial duplicating the functions of the one on the front of the camera. Nikon's 10-pin remote cord connector is also included.

Most important is the range of battery options you have with the MB-D100 Multi-Function Battery Pack connected. Where the stock D100 holds a single compact lithium-ion rechargeable battery, the MB-D100 will hold two of these batteries, doubling the already excellent battery life. Nikon claims it is possible to shoot 1600 images with this arrangement. Also included with the battery pack is a tray that holds six AA-size batteries. It is possible to use alkaline, lithium, or NiMH types, so no matter where you are in the world, there will be a way to find batteries to power the camera. An AC adapter is also available as an accessory.

Camera Functions. Camera status information is displayed on the top display panel. Four exposure modes are available, including auto-multi program (with flexible program), shutter-priority auto, aperture-priority auto, and manual. A dial on the top left of the camera is used to select these modes. Also included on the dial are controls for setting the autofocus area mode, the image quality, the white balance, and

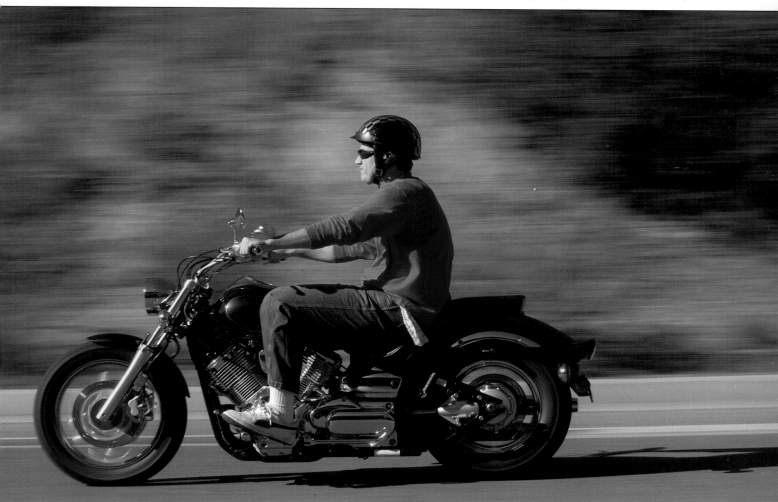

The dynamic-autofocus setting on the D100 tracks subjects as they move and the camera pans to follow.

the ISO. Available ISO speeds are 200 to 1600 in ⅓-EV increments, plus Hi-1 (3200) and Hi-2 (6400). It is also possible to access all of the settings on this dial through the menus, but these commonly changed settings are quicker to access from the dial.

A custom menu setting sets the camera to ISO-auto mode. In this mode, if the optimal exposure cannot be achieved at the ISO sensitivity set by the user, the D100 automatically adjusts the ISO in the range of 200 to 1600.

Surrounding this dial on the upper left is a shutter mode lock-release switch. This is used to select single-frame, continuous, or self-timer shooting. Shutter speeds are selectable from ¼₀₀₀ second to 30 seconds in ⅓- or ½-EV increments. In manual mode, a bulb setting is also available. Shutter speeds are selected using the main command dial on the upper right of the camera back. Aperture values are changed in ⅓-stop increments with the subcommand dial directly below the shutter release. These functions can be switched by using a custom setting.

An exposure and focus lock button is provided near the main-command dial on the camera back, and the ring surrounding it allows for the selection of metering modes. Three metering modes are available, including 3-D matrix, center-weighted, and spot metering. With some older Nikkor lenses, not all of these modes are available. An exposure compensation button is located near the release and provides compensation over a range of ±5 EV in ⅓-EV increments.

Exposure bracketing is also available, and is selected by a button on the camera back in conjunction with the subcommand dial. There are 18 possible bracketing combinations in ⅓- or ½-EV increments over a range of ±2 EV. Custom settings allow the bracketing to be done with exposure only, flash only, or both exposure and flash.

The noninterchangeable focusing screen shows five focus areas that can be selected using the four-direction button near the center of the camera's back. The D100 has both single and continuous autofocusing as well as manual focusing capabilities. A switch on the front of the camera body selects these modes.

In the autofocus modes, the D100 can be set to capture an image only when the subject is in focus in

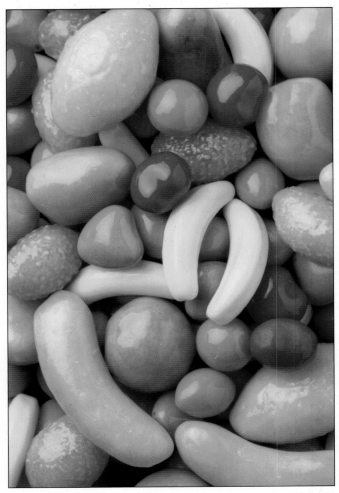

ABOVE—Although it required an accessory adapter to provide a PC outlet, the D100 delivered accurate, saturated colors when manually white balanced to studio strobes.

FACING PAGE—Since the image sensor in the D100 is smaller than a 35mm frame, close-up photos are easy to do with Nikkor macro lenses.

the selected focus area, or, if it is moving erratically, whenever it is in focus in any of the focus areas. Dynamic autofocus with closest-subject priority is also available. This mode disables the user-selectable focus areas and automatically focuses on the closest subject in any of the five focus areas. While autofocus speed is difficult to evaluate between cameras since it is dependent on many factors, the D100 is fast, but still slower than the more expensive Nikon digital SLRs.

Flash. The D100 includes a manually operated, built-in, pop-up flash with a published guide number of 38 (in feet at 100 ISO). The flash can be operated in slow-sync, red-eye reduction, slow-sync with red-eye

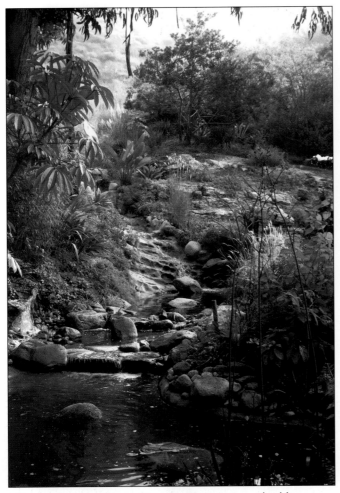

Nikon's 3-D color-matrix/multi-pattern metering is easily able to accurately expose scenes with values ranging from bright foggy skies to deep shadows.

reduction, and rear-curtain modes. A flash exposure compensation button on the upper left of the back provides flash compensation over a range of −3 to +1 EV in $\frac{1}{3}$- or $\frac{1}{2}$-EV increments. While this built-in flash is adequate for putting catchlights into the eyes, the D100 also includes a hot shoe for Nikon flash units. Photographers who do a lot of daylight fill-flash photography will be disappointed to find the maximum sync speed for flash is $\frac{1}{180}$ second.

Strangely absent in a camera clearly designed with the needs of professional photographers in mind is a PC terminal for connecting studio flash units. Nikon's optional AS-15 PC Sync socket adapter must be used in the accessory shoe to connect studio strobes to the D100. A wide range of other Nikon accessories work with the camera, including many Nikon flash models,

but again the latest flash models ensure the greatest compatibility with the full range of camera modes.

Image Playback. Digital-function status is displayed along with camera-function status on the control panel LCD on the top of the camera. On the back of the D100, directly below the viewfinder eyepiece, is a smallish 1.8-inch color LCD display with 180,000-pixel resolution. Its position below the eyepiece ensures that neither right- nor left-eyed photographers will be pressing their nose against the display.

Images can be displayed on the LCD for review immediately after they are taken, or this function can be turned off to conserve power. Custom settings allow this to be a view of the image only, a view of the image with flashing highlights, or a view of the image with both the histogram and flashing highlights. The image remains on the LCD monitor for a user-selectable time or until the user half-presses the shutter release.

To the left of the LCD is a vertical row of five buttons. At the top is the monitor button for calling up and canceling the display of the last image taken. Below it is the menu button for calling up and canceling the menu screens. Below the menu button is the thumbnail button that allows the display of four or nine images per screen. The fourth button down is the protect button, used to mark images to prevent erasure or to mark them for download. At the bottom is the enter button, used to accept menu selections. This button also functions as the playback zoom button, in conjunction with the main command dial.

Menu Options. The menus of the D100 are organized into four major menu sections: shooting, playback, custom (CSM), and setup, like the D1-series menus. While the selections are more limited, they certainly cover the range of needs of most photographers. There are 24 custom-setting options, for example, to fine-tune the camera to individual preferences. One that I particularly liked turned on a set of grid lines outside of the central viewing circle of the viewfinder. This is great help in ensuring level horizons in landscape photography and vertical buildings when using a perspective-control lens.

White Balance. The D100 offers the usual options for white balance: auto, incandescent, fluorescent,

direct sunlight, flash, cloudy, shade, and preset. For settings other than preset, and where the user selects the color temperature, it is possible to fine-tune the white balance in 10-mired increments through a small range.

Color Modes. To suit different photographer's workflows, three color modes are available. The default is mode I, an sRGB workspace suited for portrait shots that will be used "as is" or printed without adjustments. Mode II is Adobe RGB and embeds an ICC profile in the image information that imaging applications supporting color management can read. Mode III is another sRGB workspace. This one gives slightly richer greens, and is best suited for landscape or nature photos that will be used "as is" or printed without corrections.

Removable Media and Connectivity. A slot behind a locking door on the back of the D100 holds a single CompactFlash (Type I or II) or Microdrive card. Images are moved to the computer by USB 1.1.

The use of USB 1.1 for image transfer rather than the much faster IEEE 1394 (FireWire) is one of the few shortcomings of the D100. Given the sheer volume of information that must be transferred, it is unfortunate that Nikon chose USB over IEEE 1394. A video out port is also available so that images can be viewed on a television.

Software. Included in the D100 box is Nikon View software for Windows operating systems (Windows 98 SE to Windows XP) and Macintosh operating systems (OS 9.0 to OS 10.1.2 or later). The latest version of Nikon View, offering added features and bug fixes, can always be downloaded from the Nikon web site.

The Nikon View software is only used to navigate to and then view image captures, including RAW captures. Changes or corrections to the file, or conversion of the RAW captures to TIFF or JPEG are done by clicking on the edit icon in Nikon View, which opens Nikon Editor software. This program provides only

With the D100 set on fully automatic exposure, the auto white balance delivers a pleasing compromise to this capture lit by incandescent bulbs in bright shade.

minimum control over adjustments, and will not save the adjustments made to RAW files. Nikon View loads a plug-in into Photoshop, so it is possible to open captures in Photoshop directly from Nikon View.

The optional Nikon Capture software must be purchased for complete control over RAW captures. This full-featured program allows total control over RAW captures. It also includes features that will remove the distortion from captures taken with the 10mm DX fisheye lens. It also automatically removes

NIKKOR LENS COMPATIBILITY

The D1x and D1H accept a wide range of Nikkor lenses, but only the latest autofocus Nikkors, including DX-, D- and G-type, along with AF-S and AF-I Nikkors, can make use of the full range of focus, exposure, and metering modes. Older manual-focus non-CPU Nikkors can be used in aperture-priority or manual modes with center-weighted or spot metering. IX-Nikkors are incompatible with the camera. An enormous range of other Nikon accessories work with the camera, including remote-control devices, through the remote terminal on the camera front of each camera.

The D2H accepts the same range of lenses and accessories, but has improved compatibility with older non-CPU lenses. A custom setting allows the user to input focal length and aperture data for these lenses to gain access to camera functions, such as color-matrix metering and balanced fill flash, which would normally be only available to newer CPU lenses. The D2H also includes a terminal for attaching remote-control devices.

The D100 is also compatible with a wide range of Nikkor lenses, but again, only the latest DX-, D, and G-type AF Nikkors, along with AF-S and AF-I Nikkors, can make use of the full range of focus, exposure, and metering modes. While older manual-focus AI-S, AI, or AI-modified Nikkors can be used if the exposure is set manually, the exposure meter in the camera cannot be used. IX-Nikkors are incompatible with the camera.

dust specks without softening the image. Nikon Capture software is also needed in order to shoot directly from the D100 to the computer.

Conclusion. It is easy to nitpick the D100 for its N80-looking body or its USB 1.1 interface—and many photographers did so when Nikon first announced the camera. But once you use the D100, it's clear that the camera is an extremely well-designed and well-built piece of equipment, capable of delivering excellent images, and as suited to a wide range of professional applications as it is to taking along for family photos on vacation.

For one thing, the D100 is fast. It is ready to shoot the instant it is turned on. The autofocus speed is very good, if not quite up to the D1x or D2H level. Captures can be viewed immediately after they are made, though media write times are slower than other digital SLR Nikons. Zooming in on and navigating around the previews, other than those made in compressed RAW format, is very quick. Rotating one dial on the top of the camera quickly changes both the exposure modes and the most-often changed digital functions. And the five buttons on the back of the D100 speed menu access and image review.

Also in its favor is the excellent battery life of the D100. The compact, lightweight lithium-ion battery never ran out of charge in a day's shooting—even after several hundred RAW captures. With two of these batteries in the optional MB-D100 Multi-Function Battery Pack, it should be possible to shoot for several days without recharging.

With a street price of about $1500, the D100 packs a lot of features into a camera in the lower midrange of digital SLR prices. Unless a photographer needs the raw speed of the D2H or the ruggedness of the D1x, money saved by purchasing the D100 could buy a Nikkor lens and optional D100 battery pack. — S.S.

4. OTHER DIGITAL SLRs

■ KODAK DCS PRO 14N

Few announcements about digital SLRs generated the level of eager expectation created by Kodak's announcement of the DCS Pro 14n. This was due in no small degree to the time lapse between the camera's announcement at Photokina in September 2002 and its shipping date of mid-March 2003. But more importantly, its arrival was anticipated as the beginning of the Golden Age of Digital Photography—high pixel count, full-frame sensor, affordable digital SLRs for professional photographers. While the 14n has yet to live up to these high expectations, when it is used under optimum conditions, it is capable of producing exceptionally sharp, extremely detailed images at the largest file size of any digital SLR. And the 14n achieves this file size without any interpolation.

Kodak has been at the forefront of professional digital cameras since its showing of the $30,000, 1.3-

With grid lines turned on in the viewfinder and a 17mm lens delivering its full angle of view, it is easy to shoot interiors in confined spaces with the Kodak 14n.

Kodak DCS Pro 14N

With the 14n's full-frame sensor, full-frame digital fisheye photos are possible. Because this was taken with an older, non-autofocus 16mm fisheye Nikkor, it had to be metered with a handheld meter and the exposure set manually.

megapixel Nikon F3–based DCS-100 at Photokina in 1990. Since then, Kodak has introduced 12 professional digital SLRs, including the discontinued DCS 760. Kodak has clearly drawn on this long history of anticipating and responding to the needs of professional photographers in producing the Kodak DCS Pro 14n.

Kodak sent camera body specifications for the 14n to Nikon for design and manufacture. Nikon responded with a magnesium-alloy enhanced camera body based on its N80 body, but almost totally redesigned internally and weighing just over 32 ounces without lens or battery. Kodak sees the DCS Pro 14n as appealing to portrait, wedding, event, and commercial photographers shooting in controlled lighting situations.

High-Resolution Imaging. The body was designed around a 13.89 megapixel (13.5 effective megapixel), full-frame (24mm × 36mm) CMOS sensor manufactured by FillFactory nv of Belgium. Because of the sensor size, there is no focal-length magnification

factor. This is also the only sensor, other than the Foveon used by Sigma, that is not covered with an anti-aliasing filter. Other digital SLRs use this filter to minimize "jaggies" in diagonal lines and to minimize moiré patterns. The resolution of the 14n is high enough, however, that any "jaggies" present in the image are not really an issue. Software controls in Kodak DCS Photo Desk software minimize any moiré patterns present in the image.

The maximum resolution of the sensor is 4500 × 3000 (13.5 million recorded pixels), resulting in a file size of approximately 39MB (24-bit) after conversion to TIFF. (There is no provision to save data in a TIFF format in the camera itself). The 14n supports three other resolutions (3000 × 2000, 2250 × 1500, and 1125 × 750) that can be recorded in RAW format. The three highest resolutions can also be saved in standard JPEG format or in Kodak's proprietary ERI-JPEG (Extended Range Imaging JPEG) format. ERI-JPEG

With the 14n's CMOS sensor and Kodak's image-processing algorithms, both sharpness and color accuracy were excellent when photographing this flower.

retains more highlight information than standard JPEG and allows some image adjustments to be made to the file without degrading the image. Using custom settings, the user can store files as RAW, ERI-JPEG, or JPEG, and in combinations of RAW+ERI-JPEG and RAW+JPEG at various JPEG resolutions.

Shooting Speed. The maximum burst rate is 1.7 frames per second. The maximum captures per burst depends on the file format chosen and whether you have upgraded from the standard 256MB buffer to the optional 512MB buffer. With the memory upgrade, the maximum captures per burst can vary from 20 (if RAW- or JPEG-only capture is chosen) to six (if simultaneous RAW+ERI-JPEG capture is chosen).

Camera Operations. Camera status information is displayed on the LCD display panel on the top right of the 14n. Four exposure modes are available, including auto-multi program (with flexible program), shutter-priority auto, aperture-priority auto, and manual. A dial on the top left of the camera is used to select these modes. Also included on this dial is the control for setting the autofocus area mode and for adjusting the ISO setting. Available speeds are 80 to 400 ISO for full-resolution captures and 80 to 800 ISO for the lower resolutions.

Surrounding this dial on the upper left is a locking switch used to select the release mode. Available choices are single-frame shooting, continuous shooting, or

self-timer shooting. Using the custom menu, the self-timer delay can be set to 2, 5, 10, or 20 seconds.

Shutter speeds are selectable from $\frac{1}{4000}$ second to 2 seconds, in $\frac{1}{3}$-EV increments. In manual mode, a bulb setting is also available. Shutter speeds are selected using the main command dial on the upper right of the camera back. Aperture values are changed in $\frac{1}{3}$-EV increments with the subcommand dial directly below the shutter release. These functions can be switched by using a custom setting.

Firmware version 4.4.3 and later add a longer exposure feature, allowing exposures from 2 to 30 seconds. This somewhat complicated mode requires the camera be tripod mounted, since the mirror is locked up prior to the shutter opening. Only certain exposure times can be used and the only available ISO settings are 6, 12, and 25.

Near the main command dial on the camera back is an exposure- and focus-lock button; the ring surrounding it allows for the selection of metering modes. Three metering modes are available, including 3-D matrix, center-weighted, and spot metering. With some older Nikkor lenses, not all of these modes are available. An exposure compensation button is located near the release and provides compensation over a range of ±3 EV in $\frac{1}{2}$-EV steps.

Exposure bracketing is also available, selected by a button on the camera back in conjunction with the

subcommand dial. There are 12 possible bracketing combinations of two or three exposures in ½-EV increments over a range of ±2 EV.

Focusing. The noninterchangeable focusing screen shows five focus areas that can be selected with the 4-direction button near the center of the camera's back. A switch on the front of the camera body is used to select either single or continuous autofocusing, but, unlike other Nikon or Nikon-based digital SLRs, there is no setting for manual focusing. In the autofocus modes, it is possible to set the Pro 14n to capture an image only when the subject is in focus in the selected focus area, or, if it is moving erratically, whenever it is in focus in any of the focus areas. Dynamic autofocus with closest-subject priority is also available. This mode disables the user-selectable focus areas and automatically focuses on the closest subject in any of the five focus areas. While autofocus speed is difficult to evaluate between cameras, since it is dependent on many factors, autofocus speed of the 14n is comparable to that of other cameras like the Nikon D100 and Fuji FinePix S2 Pro.

Lenses. The body accepts most Nikkor lenses, but only the latest DX-, D-, and G-type AF Nikkors, along with AF-S and AF-I Nikkors, can make use of the full range of focus, exposure, and metering modes. If a compatible but non-CPU lens is used, the shutter release is locked in all but the manual exposure mode and the camera's built-in exposure metering system cannot be used. The camera's firmware contains optimization tables for many current Nikkor AF lenses to maximize image quality.

Flash. The Pro 14n includes a manually operated, built-in, pop-up flash with a published guide number of 38 (in feet at 100 ISO). The flash can be operated in slow-sync, red-eye reduction, and rear-curtain modes. A flash exposure compensation button close to the release provides flash compensation over a range of −3 to +1 EV in ½-EV increments. While this built-in flash is adequate for putting catchlights into the eyes, the camera also provides a hot shoe for Nikon flash units and a PC-terminal on the left side of the camera for connecting studio flash units.

Other Accessories. Nikon remote-control devices can also be attached using the 10-pin connector port on the lower bottom of the front of the 14n. A serial connection is also provided to connect GPS devices.

Camera Layout. Buttons used to control digital functions are arranged vertically on each side of the 2-inch color image-review LCD on the back of the Pro 14n. Only the OK and cancel buttons are offset over the familiar four-way switch used for focus-area selection in camera mode, or navigating functions in digital mode. All of the buttons extend out from the camera body, making them easy to activate intentionally—or accidentally when pressing your face against the camera back to look through the viewfinder. Firmware version 4.4.3 and later deactivate these buttons when the shutter release is half-pressed.

Menus for digital functions and custom camera settings are displayed in high-contrast monochrome on

The 14n incorporates a PC-outlet for connecting the studio strobes used for this photo of orchids. The camera automatically senses rotations about the lens axis and the thumbnail is correctly oriented in Kodak's Photo Desk software.

Delivering accurate rendition of very saturated colors is no problem for the 14n. The product setting used here delivers a higher saturation than the portrait setting.

the image LCD screen and are easily visible even in bright sunlight. Two operating modes for the Pro 14n, basic and advanced, are available. The basic mode presents only one menu with eight choices. These choices include: ISO (also selectable from the exposure-mode dial on the top of the camera); JPEG resolution (RAW resolutions are unavailable); format card; display contrast; overexposure indicator; time/date; firmware (showing current version and allowing it to be upgraded); and user mode, which allows the advanced mode to be chosen.

In the advanced mode, five tabbed menus are available: capture, review, image, tools, and CSM (custom settings). The logical, easily understood layout of the extensive menu options attest to Kodak's long experience with digital cameras. It is unlikely that most professionals would need to consult the manual.

Below the image LCD is a smaller digital status LCD. When the image LCD is used to display menus, this LCD acts as a help screen, giving brief descriptions of highlighted menu options. At other times, the digital status LCD displays capture-related information, including ISO, white-balance setting, the number of images that can be held on the storage media, the crop aspect ratio chosen, and the RAW and JPEG resolutions. When a capture is displayed on the image LCD, the digital status LCD displays information about the selected file.

Next to the digital status LCD is the media door. Slots are provided for one Type I or II CF+ compatible CompactFlash card (including Microdrives) and one SecureDigital/MMC card. Images can be saved in a number of ways: to one card until it is full, then automatically to the other card; RAW images to one card and JPEGs to the other; or the same file type to both cards for redundancy. You select the desired combination using the capture menu.

Another option in this menu controls the white-balance settings with options for auto, daylight (standard, warm, cool), tungsten (standard, warm, cool), fluorescent (standard, cool white), flash (standard, warm, cool, studio), and click balance. The crop option allows the user to choose to crop the image in-camera to 4" × 5" or 2" × 2" proportions or to use the full 2" × 3" proportion.

Two of the options available in the image menu deserve mention. The sharpening level allows the user to fully turn off sharpening, as well as giving the options of low, medium, and high sharpening levels. Turning off sharpening during portrait sittings results in beautifully soft, smooth skin texture. Painting in a little sharpening of the eyes and lips in postproduction is all that's needed.

Also in the image menu is the "looks" option that applies a tone-scale adjustment to JPEG images and tags RAW images for adjustment in DCS Photo Desk

software. Currently (firmware version 4.4.3), there are four options available: portrait, product, wedding, and event. The portrait setting provides a lower-contrast, less saturated image than the product setting. The wedding setting is based on the product setting but with enhanced shadow detail. The events look is based on the product setting's high color-hold look but with enhanced shadow detail. If the image is saved in the native 12-bit RAW format, any of the camera settings can be changed before the capture is processed to a TIFF. The selected "look" becomes part of the tag in the RAW file.

By making the appropriate selection in the tools menu, the image will be tagged to automatically display in portrait orientation if the vertical release button is used to capture the image. Fifteen other options are also available, including the choice of format for video out and intervalometer setting for selecting time-lapse photography settings.

Thirteen options are available in the custom menu, including the ability to activate grid lines in the viewfinder display.

With an image displayed on the LCD, pressing the four-way selector right or left will scroll forward or backward through the captures. Pressing the selector up or down pans through various display modes including thumbnail display, zoomed image display, and histogram/image information display. The information displayed in these modes is unique to the Pro 14n and can be of great value to the user.

The zoomed image display provides two levels of magnification, 1:4 and 1:1, along with the unzoomed image. Along the bottom of the display are readouts of RGB and luminance channel saturation information for the pixels under the panable crosshair. In the histogram display, rather than overlaying the histogram on the image, the image is reduced to a thumbnail and the histogram is shown in high-contrast black on white with a grayscale directly beneath. These two displays

Turning the 14n's sharpening completely off and using the portrait setting resulted in a beautiful smooth-skin rendition. The model held a gray card for the first exposure and the camera's click-balance eyedropper was used to white balance all subsequent exposures. The black feather boa showed no signs of noise at 100 ISO.

allow the most accurate judgment of image information of any digital SLR.

Connectivity. Captures are transferred directly to the computer through the camera's IEEE 1394 (FireWire) port using Kodak DCS Camera Manager software. Camera Manager also allows the camera to be controlled from the computer. RAW files must be processed in Kodak's DCS Photo Desk software or other software that can read the RAW format before they can be saved as TIFFs. The RAW files remain unaltered as digital "negatives." On the Windows platform, the software will install on Windows 98 SE, but Windows 2000 or XP are recommended. On the Mac, Photo Desk will run native in OS X.

The level of sophistication in Kodak's Photo Desk software is another example of the years that Kodak has been involved in digital imaging and the understanding the company has of professional photographers' needs and varying workflows. From the screen layout to the variety of controls provided, Photo Desk is one of the best imaging software programs available.

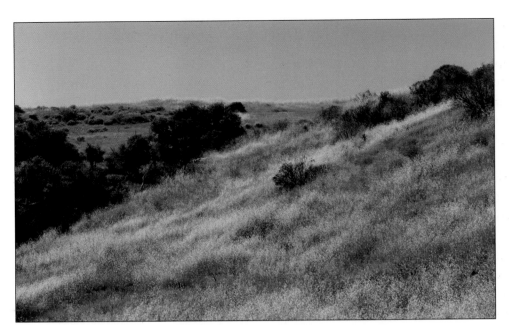

The original file from the 14n is so sharp it is possible to see individual blooms on this hillside of wildflowers.

The CD-ROM included with the Pro 14n includes the ERI File Format Module, a Photoshop plug-in that automatically launches when the user selects an ERI-JPEG. The plug-in provides most of the same ERI-JPEG controls available in the Photo Desk software directly in Photoshop. Also available from the Kodak web site is Kodak's DCS File Format Module software, a plug-in that will open Pro 14n RAW files directly in Photoshop.

DCS Custom Looks Software is available at extra cost from Kodak Professional dealers. Custom Looks is a set of ICC profiles, each of which converts the "real color" rendering of a scene to a desired response to that scene. This response can be similar to that of high-contrast film, black & white film, or black & white infrared film. Sepia toning or changing contrast or saturation options are also included.

Conclusions. Carrying the camera with its wonderfully comfortable wrist strap is no effort at all, yet the Pro 14n still feels solid and substantial in use. Balance, even with Nikon's relatively heavy 80–200mm f2.8 lens, is excellent, due to the battery mounted in the camera's wide base that results in a low center of gravity. Unfortunately, this wide base interferes with the use of perspective-control lenses on the camera.

As advanced as the Kodak Professional DCS Pro 14n digital camera is, it is not without its faults. One of these is battery life. While the battery lasts for about four hours with moderate use, it was less than would be

expected given the low power consumption of the CMOS chip. This is due to the power requirements of the 500MHz processor and the powerful digital signal processing (DSP) chip set. Even with the camera in sleep mode, these continue to draw power so that the camera will always be ready to capture.

Turning the camera off to save the battery was not an option until a recent firmware upgrade. With early versions of the 14n there was a nearly 20-second delay before the camera was ready to capture images. This involved an initial boot-up period of six to eight seconds, followed by another period of nearly 10 seconds during which the camera analyzed the ISO setting and other parameters to generate the dark noise map that was applied to subsequent captures. Newer versions of the firmware have minimized this delay, but turn-on is still slower than other digital SLRs on the market.

The whole issue of firmware deserves a mention with regard to the Pro 14n. One of the stated design goals for the Kodak DCS Pro 14n was the creation of a camera that professionals could buy with some assurance that it would be around for a while. Meeting this goal required an entirely different design approach than any other manufacturer had taken—the use of 100-percent programmable chips that allow for the upgrading of all camera functions through firmware upgrades.

Since the initial firmware release in February of 2003, there have been seven upgrades to the current

version (4.4.3), or an average of nearly one per month. Some critics have faulted the Pro 14n as a "work in progress," while others are supportive of the concept of a long-lived digital SLR camera with the ability to constantly upgrade it with new features. Potential owners of the Pro 14n need to be comfortable enough with their computer skills to download and install these upgrades in their cameras.

It is also bothersome that the back of the camera below the viewfinder eyepiece bulges out nearly ⅝-inch, requiring the user to press his face against it to see the full viewfinder image. For right-eyed photographers, this means pressing their nose against the image LCD screen, leaving it constantly greasy.

Like other professional digital SLRs, the image LCD of the Pro 14n cannot be used for composition. When used on playback, images on the 2-inch screen are bright and have sufficiently contrast in all but the brightest sunlight.

In its current configuration with the 512MB buffer, the Pro 14n is available for a street price of about $4000. The camera delivers truly outstanding image quality at low ISO settings (80 or 100 ISO) and shutter speeds from its ¼₀₀₀ second top on down to ½ second. When these conditions can be met with ambient light or can be created in the studio—when fast, continuous image capture isn't critical, and when exceptional sharpness and a nearly 40MB file is essential—the Kodak Professional DCS Pro 14n is an ideal solution. —S.S.

■ THE FUJI FINEPIX S2 PRO

Fujifilm entered the digital SLR market in 2000 with the introduction of the Fuji FinePix S1 Pro. This camera, based on the Nikon N60 body, offered a lighter-weight and lower-cost alternative to the Nikon D1 and Kodak DCS 660 for photographers interested in a digital camera to use with their existing Nikkor lenses.

The Fujifilm FinePix S2 Pro updates this earlier camera with an upgrade to a Nikon N80 body, Fuji's third-generation Super CCD image sensor, and a host

of other improvements. In creating the S2, Fuji has made a capable digital SLR that will please many enthusiasts, as well as professional photographers shooting portraits and weddings, with its ability to produce large files with beautiful skin tones.

While similar in appearance to the Nikon D100, with a similar metal frame and composite covering, the S2 Pro is quite a different camera. Where Nikon gutted the N80 to build the D100 (and the 14n for Kodak), the S2 Pro retains more of the N80, coming off as a hybrid part-digital, part-N80 camera. For example, operation requires two sets of batteries: two CR 123A lithium batteries for camera operation and four AA (alkaline or rechargeable NiMH, but not manganese or lithium) for digital operation.

The heart of the camera is Fujifilm's third-generation Super CCD, which measures 23.0mm × 15.5mm with 6.17 million effective pixels in an interwoven pattern. Where CCD and CMOS sensor elements in other cameras are square or rectangular in shape, those in the

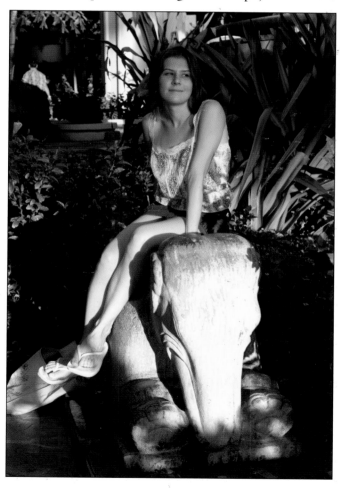

The pop-up flash built into the S2 (here set at −1EV) comes in handy for balancing the shadow areas with areas in sunlight. Note, too, the pleasing flesh tones at all exposure levels.

Fuji S2

Super CCD sensor are octagonal. The maximum resolution of the sensor is 4256 × 2848 (12.1 million recorded pixels), resulting in a file size of 35.5MB (24-bit). Fuji accomplishes this by interpolating the sensor data within the camera. Shooting at the maximum resolution produces file sizes of approximately 36MB (TIFF), 12.4MB (RAW), 4.7MB (JPEG Fine), and 2.2MB (JPEG Normal). The S2 Pro supports three other resolutions (3024 × 2016, 2304 × 1536, and 1440 × 960) that can be recorded as TIFF or JPEG (but not RAW) files at correspondingly smaller file sizes. Lens focal length is approximately 1.5 times that of the 35mm film equivalent.

A RISC (reduced instruction set) CPU and newly developed LSI ASIC (large-scale integrated application-specific integrated circuit) combine to efficiently handle the large file sizes this camera can generate. Even at the largest file size, the S2 Pro can capture two frames per second up to a total of seven frames. This rate remains constant regardless of file size. Images cannot be reviewed until the entire sequence has been written to the storage media.

Exposure Modes. Camera status information is displayed on the top display panel. Four exposure modes are available, including auto-multi program (with flexible program), shutter-priority auto, aperture-priority auto, and manual. A dial on the top left of the camera is used to select these modes. Also included on the dial is the control for accessing the custom menu and for setting the ISO. Available ISO settings are 100, 160, 200, 400, 800, and 1600, with no intermediate settings.

Surrounding this dial on the upper left is a locking release-mode switch. This is used to select single-frame shooting, continuous shooting, self-timer, or multiple-exposure shooting. The multiple-exposure mode allows the user to take as many overlaid exposures as desired in a single capture. The composite image is shown on the LCD screen, and each exposure can be saved or discarded after it is made. Multiple exposures can be made in single- or continuous-shooting modes.

Shutter speeds are selectable from $\frac{1}{4000}$ second to 30 seconds, but only in $\frac{1}{2}$-EV increments. A bulb setting is also available in manual mode. Shutter speeds are selected using the main-command dial on the upper right of the camera back. Aperture values are changed in $\frac{1}{2}$-EV increments in manual mode only, using the subcommand dial directly below the shutter release. These functions can be switched by using a custom setting.

An exposure- and focus-lock button is provided near the main-command dial on the camera back, and

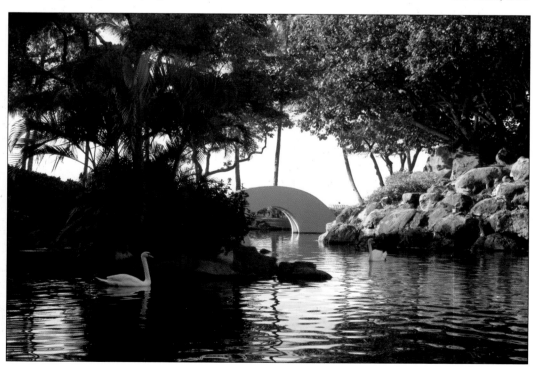

Fuji's third-generation Super CCD easily handles the wide dynamic range in this scene—from deep shadow to sunlight.

the ring surrounding it allows for the selection of metering modes. Three metering modes are available, including 3-D matrix, center-weighted, and spot metering. With some older Nikkor lenses, not all of these modes are available. An exposure compensation button is located near the release and provides compensation over a range of ±3 EV in ½-EV increments.

Exposure bracketing is also available, selected by a button on the camera back in conjunction with the subcommand dial. There are 12 possible bracketing combinations in ½-EV increments over a range of ±2 EV.

The noninterchangeable focusing screen shows five focus areas that can be selected using the four-direction button near the center of the camera's back. The S2 Pro has both single and continuous autofocus-

ing as well as manual-focusing capabilities. A switch on the front of the camera body selects these modes. In the autofocus modes, the S2 Pro can be set to capture an image only when the subject is in focus in the selected focus area, or, if it is moving erratically, whenever it is in focus in any of the focus areas. Dynamic autofocus with closest-subject priority is also available. This mode disables the user-selectable focus areas and automatically focuses on the closest subject in any of the five focus areas. While autofocus speed is difficult to evaluate between cameras since it is dependent on many factors, the S2 Pro is in the same class as the Nikon D100 but slower than the more expensive Nikon digital SLRs.

Lenses. The S2 Pro accepts a wide range of Nikkor lenses, but only the latest DX, D- and G-type AF Nikkors, along with AF-S and AF-I Nikkors can make

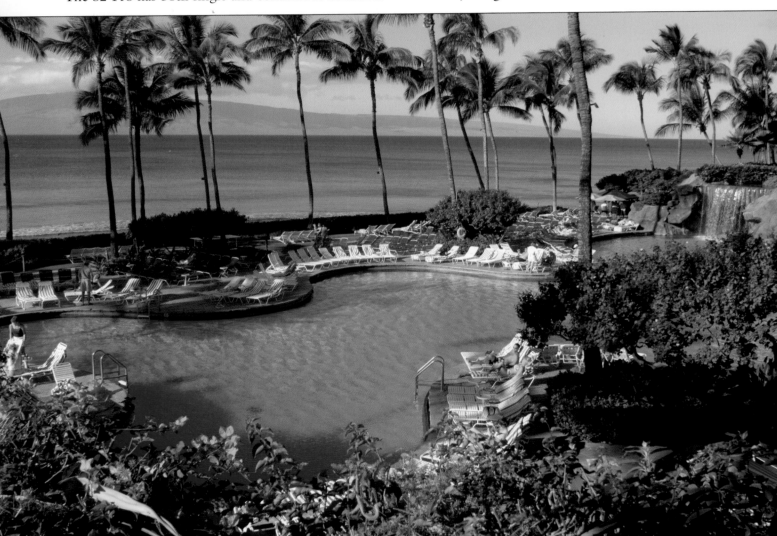

In fully automatic mode (including focus, exposure, and white balance), the Fuji S2 captures scenes with rich detail and pleasing colors.

use of the full range of focus, exposure, and metering modes. While older manual-focus AI-S, AI, or AI-modified Nikkors can be used if the exposure is set manually, the exposure meter in the camera cannot be used. IX-Nikkors are incompatible with the S2 Pro. A wide range of other Nikon accessories work with the camera, including many Nikon flash models, but the latest flash models ensure the greatest compatibility with the full range of camera modes.

The FinePix S2 Pro includes a manually operated, built-in, pop-up flash with a published guide number of 38 (in feet at 100 ISO). The flash can be operated in slow-sync, red-eye reduction, and rear-curtain modes. A flash exposure compensation button close to the release provides flash compensation over a range of −3 to +1 EV in 1/2-EV increments. While this built-in flash is adequate for putting catchlights into the eyes, Fuji also provides a hot shoe for Nikon flash units and a PC-terminal on the left side of the camera for connecting studio flash units.

Digital Functions. Digital function status is displayed on the rear panel display above the LCD screen. To the left of this screen, which glows with a soft orange backlighting when illuminated, is a function button that cycles through the eight choices that can be displayed on the screen. These choices include those that are most-often changed, such as white balance, autofocus area, image-capture quality, image-capture size, color saturation, contrast, sharpening, and a setting to lock the selected functions. Buttons below the display cycle through the options for each of the eight settings.

Seven white-balance settings are available. They include auto, fine (sun), shade, incandescent, three modes for fluorescent light, and the ability to save two custom settings.

The play button, immediately below the function button, initiates playback. When an image is displayed, the rear panel displays four new icons: a histogram, a trash can, a key to mark the image for protection, and a multi-frame playback that displays nine images at a time on the LCD. The histogram is worthy of mention as it can display not only the composite histogram, but can also be cycled to display separate histograms for red, green, and blue. The four-direction button on the

camera back is used to move forward, backward, or to the first and last image captured.

With an image displayed full screen, pressing the four-direction button right or left takes you to the next or previous image. Pressing the four-direction button up zooms the image to an extremely high magnification. Once magnified, pressing the play button allows the image to be panned left, right, up, or down by pressing the appropriate direction on the four-direction button. Pressing the four-direction button down, as long as panning is not selected, can zoom out the image. To cancel any operation there is a "back" button just above the four-direction button.

One final control on the camera back, the menu/OK button is used to access the setup menu of seldom-changed functions. The setup menu is displayed on the imaging LCD. From this menu, options such as voice memo activation, custom white-balance, and date/time settings are available. Options for the 15 custom camera settings are also displayed on the image LCD.

With fewer choices available in the S2 Pro than many other digital SLRs, the camera is easier to learn and more intuitive to operate. The choices provided are well documented in the manual, which also provides hints to getting the most out of the camera.

Removable Media. Fuji recommends recording to either SmartMedia cards or Microdrives, cautioning that some CompactFlash cards might not work. However, we experienced no problems using a variety of Lexar and SanDisk cards. Hidden behind a latch-operated door on the camera back are dual media slots, one for each type of card. The user can select from the menu options which media to which to record, but images cannot be recorded to both media simultaneously, as they can in some other digital SLRs. Images are moved to the computer either by USB 1.1 or the much faster IEEE 1394 (FireWire) connection.

Connectivity. Included with the S2 Pro is a CD containing the FinePix Viewer program. Supported operating systems are Windows 98 SE, Me, 2000 and XP, as well as Macintosh OS 9.1, 9.2.1, and OS X. The FinePix Viewer facilitates the downloading of images to the computer, plays back voice memos, and allows CCD-RAW files to be played back and converted.

Even at the 1600-ISO setting, the Fuji S2 delivers good sharpness at very acceptable noise levels for available-light shooting.

Software. Unfortunately, the RAW file converter in the Finepix Viewer software is an optionless function that automatically converts the RAW file to a 36MB 24-bit sRGB file using the digital function settings from the time of capture. While this is a quick and simple solution, to take full advantage of the Fuji RAW format it is necessary to purchase the optional Hyper-Utility software. This program gives greater control over the RAW data as well as the ability to save the image as an 8-bit per channel sRGB or 16-bit per channel Adobe RGB file. Also included in this software is the ability to capture images directly to the computer through an IEEE 1394 cable.

Conclusion. With a street price of about $2000, the cost of the Fuji FinePix S2 Pro lies in the mid-range of digital SLR prices. Although its less rugged plastic body and slower capture rate would not make it the best choice for photojournalists or sports photographers, it is capable of producing an image file that is second only to the Kodak 14n in sheer size. And while this size is a result of interpolation, when processed as RAW files in Fuji Hyper-Utility software, there is real resolution there, exceeding that of digital SLRs costing more than twice as much. For nature and landscape photographers who don't need fast capture rates and who can appreciate a compact, lightweight camera body, the S2 Pro should work extremely well.

Despite the common belief that digital cameras somehow, unlike film, capture colors "accurately," anyone using a variety of cameras knows that no matter how carefully they are custom white balanced, they all produce a certain "look." The S2 Pro is no exception. What it gives up in absolute color accuracy it makes up in its rendition of skin tones and surface textures. For this reason, portrait and wedding professionals should find this camera very appealing. Its ability to produce file sizes appropriate to producing large prints adds to its appeal. The only drawback to this market is the lack of a portrait grip and vertical release.

Overall the Fuji FinePix S2 Pro is an excellent choice for large segments of the professional wedding and portrait market and for photo enthusiasts with a stock of Nikkor lenses. —S.S.

◼ OLYMPUS E-1

The Olympus E-1 and its lenses are the first product in what's being called the "four-thirds" standard (see sidebar on page 102) which Olympus first introduced at the 2002 Photokina in Germany. There were prototypes shown at PMA in early 2003, and the system was announced publicly at a major roll-out in mid-2003 in New York.

The E-1 performed very well, right out of the box. It was fast and responsive. As would be expected from

Olympus products, image quality was excellent. The camera that the E-1 will probably be compared with most often is the E-20. With lens attached, at 48 ounces, the E-1 is only two ounces heavier than the E-20n, and it looks somewhat similar. While they are similar in size, weight, and looks, the similarities are primarily cosmetic. There's no real comparison between the two.

The magnesium-alloy E-1 wasn't a revamping of anything else, either film or digital. Unlike the digital components of film-equipment manufacturers, which are redesigned film bodies and lenses, the new system from Olympus isn't a hybrid design solution, where bodies and lenses that were initially designed for film cameras were redesigned as digital equipment.

From its electronics to its optics, it is a totally new system specifically optimized for digital shooting. That's a big plus, since image capture capabilities are optimized. For example, electronic image sensors cap-ture light somewhat differently than film does. When shooting film, the light coming in through the lens can hit the film from an angle. With a sensor, image quality is enhanced if the light comes in on a more direct path. There are a number of similar design considerations that ensure superior image quality.

Even though it's considerably smaller than other digital SLRs, it has the feel of shooting with a film camera. The E-1 was designed around a 5.5-megapixel, full-frame transfer, primary CCD with an aspect ratio of 4:3, a diagonal measurement of 22.3mm, and dimensions of 17.4mm × 13.1mm. With a maximum resolution of 2560 × 1920 pixels, it has an effective resolution of 5.0 megapixels. Captured images are processed in the camera's proprietary system, consisting of three ASIC digital processors. Such parallel processing increases throughput while reducing bottlenecks. A special supersonic wave filter keeps dust off of the image sensor using ultrasonic vibrations.

The E-20n was the first true digital SLR from Olympus. It was a strong camera with a lot going for it. But it didn't have interchangeable lenses.

Olympus E-1

Professional Controls. The E-1 has all the creative control that a professional is looking for, including multiple exposure options, a number of metering choices, and selectable focusing settings. Depending upon the shooting mode, shutter speeds range from $\frac{1}{4000}$ second all the way up to 60 seconds. There is also a bulb setting.

The exposure mode is selected with the mode dial on top of the camera. The four options include program, aperture priority, shutter priority, and manual. Exposure compensation of ±5 stops is available, in $\frac{1}{3}$-, $\frac{1}{2}$-, or full-stop increments. Exposure setting changes are displayed both in the data LCD and in the viewfinder. Between the data LCD on top of the camera, the viewfinder, and the image LCD, the E-1 provides a tremendous amount of information and feedback to a photographer. There are the expected things like exposure, focusing-confirmation, and file-format settings. Also included are indicators for the shooting mode, battery level, the color space, the ISO setting, the white-balance setting, and selected flash mode.

Even a histogram is available.

When shooting in the automatic mode, the ISO range extends from 100 to 400. In the manual mode, it goes up to 800, which can be boosted electronically all the way up to 3200. Both exposure and white-balance bracketing are available, with the number of frames to shoot for each sequence, the frame-to-frame variation on exposure bracketing, and the light-temperature range being adjustable.

The E-1 also has something that Olympus calls "versatile color-adjustment modes," which include five saturation-adjustment modes and four color-memory modes. These adjustments make it possible to set personal preferences in the level of saturation and color rendition. That's a helpful feature. For example, a photographer who primarily shoots scenics can set the saturation higher, for those rich landscapes. Conversely, a photographer who specializes in portraiture can set the color memory for subtle flesh tones.

The camera has a TTL full-aperture metering system with both center-weighted averaging and spot-

The E-1 worked well, even under challenging lighting conditions and difficult shooting situations, right out of the box.

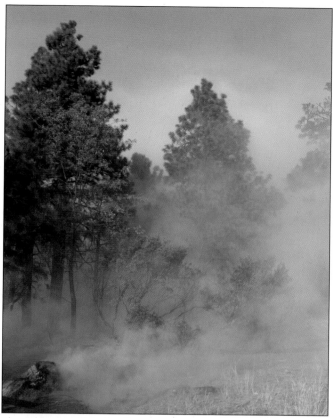

The Olympus E-1 is the first camera in the four-thirds format that Olympus hopes will become a standard in digital SLR photography.

metering options. The AEL button locks exposure settings for when there's the need to reframe, but the same exposure settings are desired. It acts like a toggle switch, locking it either on or off so there's no need to hold the button down to lock exposure. The AF frame-selection button makes it possible to manually select one of the individual focusing points. The sub (selector) dial pages through the focusing points.

Focusing. The focus-mode selector, on the lower left-hand side of the body, determines when autofocus is set and locked (in the S setting) or continues as an object is being tracked (C setting). One way of testing to see just how fast it refocuses is by putting your hand up in front of the camera and either moving it back and forth or quickly out of frame so that the focus shifts from near to far. Overall, focusing response was good, even though the camera seemed to hesitate every once in a while. There's also a mode for manual focus (M setting). The focusing range at 100 ISO is 0–19 EV. Once all the different camera options have been set, it's possible to store that configuration. Up to four differ-

ent personal configuration sets can be stored and recalled through menu access.

Shooting Speed. Even though the camera's specs say that it can store 12 frames in its buffer for all file formats, the test camera could only store seven RAW and five TIFF images. A buffer counter in the data LCD on top of the camera indicates the total buffer space that's available. While things like resolution and exposure controls are important, digitals have a reputation for being sluggish, so speed and responsiveness are two of the most important considerations for professional photographers.

The first thing that somebody will notice when shooting with the E-1 is precisely that—its speed and responsiveness. It is rated at three frames per second up to a maximum of 12 frames. It was able to meet that frame rate without a problem. In the continuous-shooting mode, it's as responsive as a film camera—at least until the buffer is full. In the single-frame mode, it slowed down a little after the buffer filled up, but it was possible to continue shooting at a relatively good pace. Occasionally, when shooting JPEGs, the camera hesitated briefly as it was writing captured data. In the SHQ (super high quality) mode, I was able to shoot 20 frames in 30 seconds and 42 in one minute. That number increased to 26 frames in 30 seconds and 48 frames in one minute in the HQ (high quality) mode.

The E-1 is also able to capture uncompressed images in the TIFF and RAW formats. In those modes, writing times increased. Once the buffer was full, shooting was somewhat sluggish as individual frames were being pulled off of the internal memory and written to the card. The total number of shots that could be taken in 30 seconds and one minute are 16 and 25 in the RAW file format, and 17 and 21 frames when shooting TIFF.

Menus. The menus are quite detailed, but the menu structure itself isn't particularly complex. To access the different options, there are 41 menu options divided into four main groups. The options in the first setup menu include such things as the EV-step selection, the ISO-boost option (which enables the camera to shoot all the way up to 3200 ISO), and the dial-assignment selection. The second setup-menu options include card setup and file management.

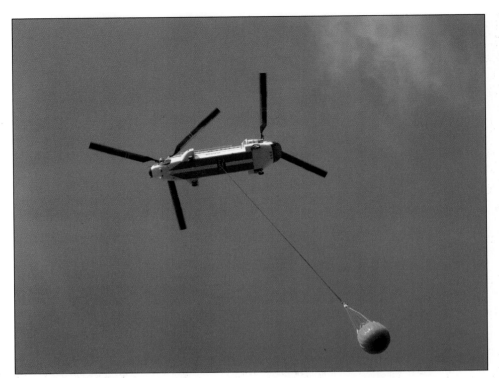

With the lens conversion factor, a 300mm lens has the same coverage as a 600mm lens has on a 35mm camera. A 300mm lens is much easier to work with when handholding the camera than a 600mm lens.

Another menu sets the shooting options, such as the saturation level, the contrast, the color space that images are being captured in (either sRGB or Adobe RGB), white balance, and noise reduction. The playback menu includes a slide-show selection, an auto-rotate feature, and a RAW-data edit option that takes the captured RAW file and post-processes it into a TIFF or JPEG image.

Viewfinder. The viewfinder's full 100-percent coverage ensures accurate framing, while its adjustable diopter (–1 to +3 range) makes it easier for people with vision problems to see. There's also an eyepiece shutter lever to block out the light coming through the viewfinder, for when the camera is being fired remotely or with a timer.

Weather Resistance. Olympus has been on the leading edge in making sure its cameras will continue working, even under adverse weather conditions. Many of its smaller clamshell cameras have been weatherized. With extensive gaskets and seals, the E-1 also has a certain amount of weatherproofing designed into it.

Removable Media. Images are stored on removable CompactFlash cards. The E-1 takes CF Type I, Type II, and Microdrives. While actual totals differ because of frame-to-frame variations in compression, the camera indicates that it can store 96 RAW images,

63 TIFF images, 256 (SHQ compressed) or 801 (HQ compressed) JPEG images on a 1GB CF card.

Flash. The E-1 does not include a pop-up flash, which is surprising for a camera targeted at the serious amateur market. However, it does have a hot shoe as well as an X-attachment external flash connector. Off-camera flash synchronization is $\frac{1}{180}$ second or less. Flash-control modes include TTL-auto (through the lens pre-flash), auto, and manual. The company's FL-50 flash integrates very effectively with the E-1, making it possible to control flash intensity and firing time through the camera. The E-1 will also accept other flash units, but controls that are available with them through the camera are limited.

Lenses. The body used for this review came with one of the new Zuiko Digital 14–54mm/f2.8–3.5 lenses (giving it the same coverage as a 28–108mm on a 35mm camera) with macro capabilities. It's an excellent lens with a great coverage range.

Edge deterioration is one of the problems that frequently comes up with lenses that were designed for film cameras and adapted for digital cameras. Since the dimensions for CCDs in digital SLRs are generally smaller than the dimensions of 35mm frames, most, but not all, of the deterioration is clipped outside of the CCD frame.

Sophisticated electronics, accurate metering, and reliable focus tracking in a small package makes the E-1 the logical choice when only one camera is going to be carried along.

The E-1 lenses, which were specifically designed for this camera, are exceptional pieces of glass. The lens that was tested was sharp, edge-to-edge and corner-to-corner. Other lenses that are available for it now are an ED 50–200/f2.8–3.5), an ED 50mm/f2.0 macro, and an ED 300mm/f2.8. An 11–22mm wide-angle and an ultrawide zoom should be available by the time this book is in print.

Since the lenses were designed specifically for the E-1 body, they couple very effectively with it. There's continuous data exchange between the camera and any lens that might be attached to it. A 1.4× teleconverter can be used to extend the zoom range of the different lenses. With the smaller sensor of the E-1, the 35mm equivalent coverage is exactly twice as much as the actual lens coverage. The 300mm, for instance, has the same magnification as a 600mm lens on a 35mm camera. There's also an adapter available that makes it possible to mount Olympus OM lenses onto the E-1, but that wasn't tested. It would be safe to say that many of the advantages of going with digitally designed systems from the ground up would be lost with lenses designed for film cameras.

Connectivity. Images can be downloaded to Macs or PC systems either through the USB 2.0 or the FireWire (IEEE 1394) port. Images can also be sent to a video device, for which both NTSC and PAL formats are supported. The camera gets its power from a proprietary rechargeable lithium-ion battery. The battery life was very good. It was possible to shoot a full day, without having to change the battery.

Pricing. The E-1 is selling for around $1700, while the 14–54mm lens costs $599. Prices for the macro, the telephoto zoom, and the 300mm are $599, $1199, and $7999, respectively. A wireless remote control is available

Conclusion. The Olympus E-1 is an excellent piece of equipment and a good choice for photographers who don't already have a large investment in a film system, or those that are looking for a way to add digital capabilities without necessarily wanting to integrate them into their film gear. With its high-quality images, wide range of creative controls, simple-to-use layout, and smaller size, it's a good choice to carry along when traveling for work or pleasure. —*R.E.*

THE FOUR-THIRDS STANDARD

The E-1 was the first digital SLR from Olympus with interchangeable lenses, but it wasn't the company's first digital SLR. Olympus has had several models on the market. Even though they had their limitations, cameras like the E-10 and E-20n, with their high resolutions and excellent optics, were well suited for certain types of professional applications. The E-10 and E-20n were part of a long-term strategy by Olympus to go after the professional photography market, and they were really only the first steps.

According to sources within the company, about four years ago, the decision was made at the highest levels to become a major player in professional digital imaging. What came out of that planning was the four-thirds (referring to the aspect ratio of the sensor) open standard, a new, smaller digital camera standard. The company first openly talked about this standard at Photokina in Germany in 2002. The idea was presented in the U.S. at PMA early in 2003.

Olympus was going to develop the technology for the standard and release the specs to any other companies interested in manufacturing compatible equipment. The expectation was that, eventually, there would be a wide selection of compatible bodies, lenses and accessories from a host of different suppliers.

Olympus has come out with the first body and series of lenses for that standard, the E-1 system, but there hasn't been an overwhelming rush by other manufacturers to the new standard. It's still early. If the E-1 winds up being even moderately successful, no doubt other equipment manufacturers will want to be a part of that.

■ THE PENTAX *IST D

For many photographers starting out in the 1960s and 1970s, if they didn't own a Pentax Spotmatic it was on their wish list. While Pentax film cameras never garnered the following that Nikons and Canons did among professionals, it wasn't for any lack of quality in Pentax lenses or for a lack of system accessories. Professionals did embrace the Pentax 6cm × 7cm camera system with its line of extraordinarily sharp lenses that launched the whole 6cm × 7cm movement.

So, a digital camera from Pentax has been eagerly anticipated. Not long ago the company announced the development of a full-frame sensor camera, then apparently abandoned it to bring out the Pentax *ist D.

The *ist D is the smallest, lightest digital SLR currently on the market, weighing in at a mere 19.4 ounces without batteries or lens. In size, it is only 5.1" × 3.7" × 2.4".

Image Sensor. Its CCD sensor measures 23.5mm × 15.7mm with 6.1 effective megapixels. Three resolutions are immediately available when using the camera: 3008 × 2008 (large), 2400 × 1600 (medium) and 1536 × 1024 (small). Two other options for the small resolution are available through the custom menu: 1152 × 768 and 960 × 640. All available resolutions can be stored in TIFF format or one of three qualities of JPEG. The highest quality setting can also be saved in RAW format.

Pentax *ist D

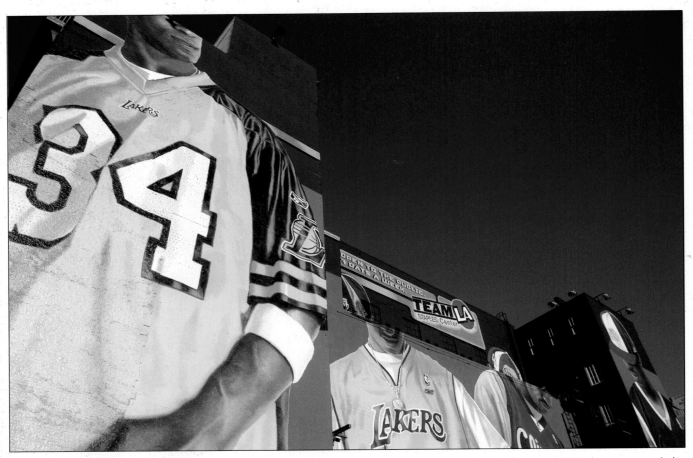

Responsiveness. When powered on, the *ist D is ready to capture images in about three seconds. Shutter lag is noticeable unless the subject is prefocused by half-pressing and holding the shutter release partway down, indicating that the delay is primarily due to focusing. The capture rate is constant at about 2.5 frames per second, but a small buffer limits the number of continuous captures in RAW and TIFF modes to five. With TIFF captures, it is possible to capture additional frames at a rate of about one per second thereafter. With RAW captures, you must wait nearly ten seconds after the burst to capture another frame. Using a 40× Lexar CompactFlash card, since the *ist D supports write acceleration, would have reduced these times.

Batteries. Batteries in the grip provide power for the camera and digital operation. Without additional adapters, the grip will hold two lithium CD-V3 batteries (which provide the longest life), or four AA-size batteries (lithium, alkaline, or rechargeable NiMH).

The camera's battery life is excellent and can be further extended with the optional D-BG1 battery grip

ABOVE—While it was the smallest digital SLR that was tested, the Pentax *ist D provided outstanding performance and very good responsiveness.

FACING PAGE—Pentax built a strong reputation with its Spotmatic 35mm film cameras. Its first venture into digital SLRs is proving to be very successful.

that holds another identical set of batteries. This battery grip mounts below the camera and includes a vertical release button and an auto-exposure lock button, along with shutter speed- and aperture-adjusting dials.

Exposure Modes. There are five exposure modes available. One of these is a programmed auto-exposure mode, indicated by a green bar on the dial at the top left of the camera, that is used to select exposure modes. This mode turns the feature-rich *ist D into a point-and-shoot camera, a mode probably of little value to the enthusiasts to whom this camera will appeal. The other modes available are hyper-program (H), shutter-priority (Tv), aperture-priority (Av), and hyper-manual (M). In hyper-program mode, exposure is set automatically, but the photographer can use the

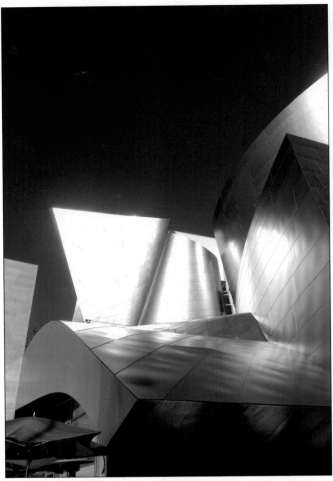

The camera was very good at focusing. It didn't get confused, even when focusing on reflective materials, which can cause some focusing systems problems.

shutter-speed dial (Tv) on the front of the camera or the aperture-setting dial (Av) on the rear of the camera to change the automatic setting while keeping the proper exposure.

Hyper-manual mode works in a similar manner. If M is selected on the mode dial, the photographer can push a small green button close to the release. The *ist D will select the combination of shutter speed and aperture that will yield the proper exposure. The photographer can then use the Tv and Av dials to change the shutter speed or aperture independently of one another.

Exposure accuracy in a variety of situations was excellent. Data is integrated from a 16-segment metering array for exposure determination. Center-weighted and spot-metering modes are also available. Rotating a non-locking dial surrounding the mode dial selects the

metering mode. Pressing a button next to the Av dial on the back of the *ist D allows the user to set exposure compensation over a ±3 EV range in ½-EV steps.

The *ist D also offers three-frame bracketing. Pressing and holding a button below the mode dial while rotating the Tv dial on the camera's front selects the autobracketing mode. Rotating the Av dial selects the compensation in ½- or ⅓-EV steps, selectable through the custom settings.

The same button below the mode dial is used to select multiple-exposure mode. As the captures are made, the composite image is displayed on the LCD monitor on the back of the camera. From testing this feature, it seems that as much time as needed can be taken between exposures—as long as the camera does not go into sleep mode before the sequence is complete. Two to nine frames can be superimposed, but determining the exposure is left to the photographer.

Available shutter speeds range from $\frac{1}{4000}$ second to 30 seconds in ½-EV or ⅓-EV increments, selectable through a custom setting. A bulb setting is also available on the mode dial. Aperture values are also selectable in ½-EV or ⅓-EV increments. Flash synchronization is available up to $\frac{1}{150}$ second.

ISO settings are also adjusted from a position on the mode dial. The *ist D provides ISO settings of 200, 400, 800 and 1600 with no intermediate values. A custom setting extends the range to 3200.

White balance is selected by using another position on the mode dial. Rotating the Av dial while in white-balance mode moves a triangular pointer over a series of icons printed below the top LCD panel. It is possible to choose from eight settings: daylight, shade, cloudy, fluorescent, incandescent, flash, and custom. In the fluorescent mode there are three available settings. It is also possible to store three custom white balance settings.

Focusing. Autofocus modes are selected by rotating the non-locking ring surrounding the four-way controller dial on the back of the camera. In auto mode, the camera selects the focus point. This seemed to be completely random, not consistently selecting the nearest point as some systems do, nor the brightest point, nor the highest contrast point. Auto works well for photos of people or landscapes and will track focus

in continuous autofocus mode, but at other times, one of the other modes will work better.

Brackets in the noninterchangeable focusing screen show the general area of the 11-point autofocus system of the *ist D. Rotating the dial to "Sel" and using the four-way controller allows you to select which of the 11 focus points to use. The selected sensor is briefly displayed as a red square as the controller is panned through the 11 positions. The third position on the dial locks autofocus on the center sensor.

In any autofocus mode, half-pressing the shutter release locks the focus and allows the image to be recomposed. Next to the viewfinder window is an autofocus button that can also be used to lock focus. A switch on the front of the camera is used to select single- or continuous-mode autofocus. The same switch is used to select manual focus for difficult subjects or when using non-autofocus lenses.

Lenses. A wide range of Pentax lenses can be used on the *ist D, including K-, KA-, KAF-, and KAF2-series lenses. With the proper adapter, even screw-mount, 645-, and 67-series lenses can be mounted, although some camera functions will not be available. Pentax is also designing a new DA series of lenses optimized for the *ist D sensor.

Flash. The *ist D includes a manually operated, built-in, pop-up flash with a published guide number of 54 (in feet at ISO 200). Flash modes available depend on the exposure-mode setting. Automatic, slow-sync, red-eye reduction, and flash-on are possible, as well as wireless and high-speed modes when the camera is used with the optional AF360FGZ Pentax flash unit. Unfortunately, no flash exposure compensation adjustment is available on the camera. The *ist D also provides a hot shoe for Pentax flash units as well as a PC-terminal on the left side of the camera for connecting studio flash units.

Digital Functions. Digital-function status is displayed along with camera status on the top LCD screen. This makes for tiny icons that required several trips to the manual to decipher. Images and menus are displayed on the 1.8″ color LCD on the back of the *ist D.

There are four playback modes. The single-frame mode displays captured images one by one and allows

the photographer to magnify a selected image up to 12×. In multi-frame mode, the photographer can view nine recorded images simultaneously. The quick view mode shows a just-captured image for one, three, or five seconds, and the slide-show mode automatically displays captured images one after another at an interval of 3, 5, 10, 15, 20, or 30 seconds.

Four buttons to the left of the LCD function are used to call up the menus, delete images, display information (camera settings if no image is displayed; a histogram if one is), and play back images.

Pressing the menu button displays a list of 16 of the most commonly needed controls for general functions (such as formatting the media card and setting the date and time), three digital functions (color saturation, sharpness, and contrast of captured images),

The Pentax *ist D is a compact model with a wide range of professional features and capabilities, but is still easy enough for anybody just getting into photography to use.

The light weight and compact size of the *istD make it ideal for street and urban shooting.

and timing functions (such as image-review time and power-off time).

The main menu provides access to three identical sets of custom-menu options. Different selections can be made in each of these custom-menu families for different shooting conditions and, later, can be immediately accessed by choosing the appropriate custom set from the main menu. In total, there are 22 possible options in each of the three custom-setting menus.

Removable Media. Behind a latch-operated door on the right side of the camera back is a single slot for a Type I or Type II CompactFlash card or a Microdrive. Cards slide in with their tops facing the front of the camera, with the slight groove in the end of the card also facing the front of the camera. While this doesn't pose too much of a problem with Type I cards, removing the thicker Type IIs and Microdrives is a problem. I found it was necessary to hold the camera vertically and bang on it in order to remove my Microdrive card.

Connectivity. USB 1.1 is used to move the images from the *ist D to the computer. On Windows computers, Pentax recommends Windows Me/2000/XP Home or Professional, but not Windows 95/98/NT. On the Mac, OS 9.0 or later (including OS X) is recommended.

Software. Included with the *ist D is Pentax Photo Browser for viewing files from the camera and Photo Laboratory for adjusting and converting RAW images. While neither of these programs provides the levels of functionality or control that bundled software from some other manufacturers offer, they supply the basics. Photo Laboratory, for example, will not save adjustments made to the RAW file in the Pentax RAW format, only in the eight- or sixteen-bit TIFF or JPEG format. Pentax Remote Assistant software is available at additional cost and allows computer control of the *ist D.

Conclusion. A latecomer to the party, and with a street price of around $1700, the Pentax *ist D is up

against some stiff competition. Speed of operation, be it autofocus speed, image review speed, or image transfer speed, lags behind that of the competitors in its price range.

Image quality is good, but contrast and color saturation need to be increased in post-production. Captures are somewhat soft, though image noise is relatively low even at 400 ISO.

Battery life is very good and would be even better with the optional battery grip, D-BG1. This would also add some additional mass to the camera, making it better balanced with heavier lenses.

Photographers who prefer a heavier camera or who have large hands should look elsewhere. Even with relatively small hands, the four-way control can be tricky to operate. It is easy to press the OK-selection button in the center of the control accidentally when navigating through the menus, turning off the LCD and requiring you to begin again.

However, small, lighter-weight cameras from Pentax and Olympus have been popular with a large number of photographers for years, so the *ist D should appeal to them as they move to a digital SLR. Additionally, the compatibility of the *ist D with a large number of the outstanding Pentax lenses in existence will broaden its appeal. —S.S. *(Photos: R.E.)*

■ SIGMA SD10

Although Sigma is generally considered a second-tier photo-equipment manufacturer, it's still well-known among photographers. Many shooters who don't have the budget for the selection of lenses that they want for their Nikon or Canon cameras turn to Sigma for their lenses. The company has a complete selection of glass, ranging from specialty wide-angle and macro lenses, to compact zoom lenses, to very long telephoto lenses.

What many people don't realize is that Sigma isn't just a lens company. It also manufactures and markets

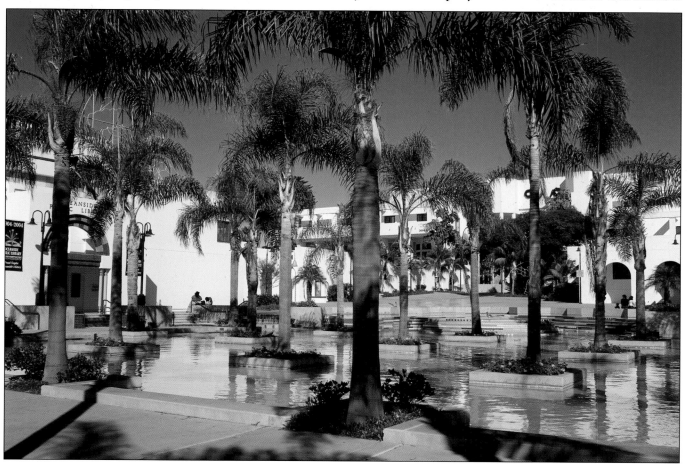

The Sigma SD10 is the only camera in this book that uses Foveon's new X3 CMOS sensor. Because of the way that the sensor was designed, its effective resolution is three times as high as the number of sensor positions in the chip.

Sigma SD10

camera bodies, including two digital SLR models: the original SD9 and the newer SD10. Together, the Sigma 35mm SLRs, an assortment of Sigma lenses, and the digital SLRs make a complete camera system.

Sigma's SD10 is a full-sized digital SLR. At 27.7 ounces (without batteries) it's on the bulky side, but it's still comfortable enough to shoot with.

Image Sensor. The SD10 uses a 20.7mm × 13.8mm Foveon X3 CMOS sensor with a maximum individual sensor resolution of 2268 × 1512 pixels. That gives it the same aspect ratio as 35mm film. Since the sensor can capture three layers of data at each sensor position (see page 112 for additional details on how the Foveon X3 chip functions), the effective resolution is 10.2 megapixels. Image quality was very good. The Foveon sensor captures sharp, crisp, and clear digital data.

While either high, medium, or low resolutions can be selected, photographs can only be captured in the

RAW file format. That's increasingly the file format of choice for serious photographers, since all of the digital data is captured and written to the removable media, without any of the in-camera post-processing or compression that can deteriorate image quality. In the RAW file format, it's possible to make any modifications to an image—such as white balance, sharpening, and exposure control—without causing any image degradation.

The camera ships with Photo Pro 2.0, which can be used to optimize and convert the RAW files into other file formats. It's unusual, though, just to be able to capture images in the RAW format, particularly considering the market segment that the SD-10 is primarily applicable for. It's a camera that would probably most appeal to photographers who are already using Sigma 35mm cameras, or photographers whose applications aren't too demanding. Only being able to cap-

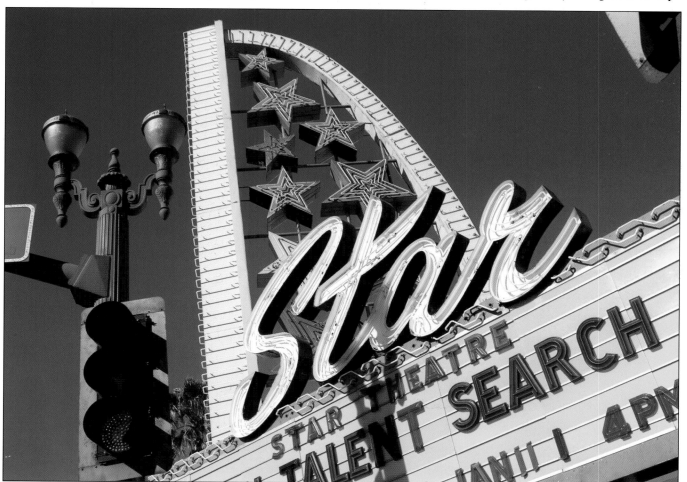

The Sigma SD10's CMOS sensor captured rich, saturated color. It's the right choice for any photographer already using compatible Sigma 35mm SLR camera gear.

ture in the RAW format has its drawbacks, since the images have to be brought into a program that can handle the RAW files before they can be shared or distributed. Images in more generic file formats, such as TIFF and JPEG, may not have the same quality potential that the RAW files do, but they can be made use of immediately. That's an advantage, particularly when shooting on the road.

Layout. There are two LCDs on the body: a small data LCD located on the top of the camera (which displays exposure data and shooting information) and a color preview/review LCD for picture display and menu settings.

The menu structure is simple and straightforward. There's only one main menu, rather than having multiple menus with several layers of submenus. The 20 menu options are accessed through the buttons on the left-hand side of the LCD, selected by the directional four-way navigational buttons on the right and confirmed or rejected by the two buttons to the lower

right of the LCD. Menus set a number of the camera's function, making it possible to do such things as control white balance, determine preview and review image options, and format CompactFlash cards. There are also extensive creative controls available. For instance, there are eight white-balance options, including auto, sunlight, shade, overcast, incandescent, flash, and custom.

Unlike some other digital SLRs, the menu options don't control things like the ISO and the shooting resolution. Those things are controlled by a vertical row of buttons on the back of the body. Pressing the appropriate button activates the specific function. Then it's just a matter of adjusting the rotating dial under the shutter release to change the setting. That makes it quick and easy to change any of shooting settings.

There are two main dials on the top of the body: drive (D) and shutter (S). The drive dial is used to set things such as the single- or continuous-shooting mode and the autobracketing. It can also be used to set

THE FOVEON X3 CMOS CHIP

In some respects, the X3 is revolutionary. It's not only different than CCDs, it works totally differently than other CMOS sensors—without the complexity and cost of those systems. It is the first full-color image sensor that captured red, green, and blue light at each individual pixel position. Instead of using color filtration to capture those RGB color values, the X3 is able to capture all three primary colors simultaneously. Individual channels are captured by different sensor layers in each pixel.

Because of the specific properties of silicon, which absorbs different light wavelengths at different depths, the sensor is able to use pixel-well depth to determine RGB values. Each X3 sensor consists of photo-detectors located at different depths within the position. Each detector measures the red, green, and blue light that has penetrated the silicon to that specific depth. Blue light is absorbed near the surface, green light is absorbed farther down, and red light is absorbed even deeper. The three-color combination sensor makes it possible to capture complete, true-color images without having to use a color mosaic filter. Because there are three RGB values generated at each pixel positions, the resolution is sometimes quoted as being three times the actual number of pixels on the sensor.

It's important to remember that the increased resolution is not an interpolated resolution. It is the actual digital data that is captured by the sensor. The individual photo-detectors convert the absorbed light into three signals. Those signals are converted to digital data, which is then optimized through software. According to the company, the X3 CMOS image capture and optimization process results in higher quality and sharper images, as well as better color. It also eliminates the color artifacts that can be a problem with other CMOS and CCD sensors. Foveon had a line of high-end professional digital cameras on the market, but it dropped them in favor of concentrating on X3 chip development. Sigma has designed Foveon chips into its SD9 and SD10—the only digital SLRs that currently feature this technology.

Metering was very accurate, even when the composition included both heavy shade and sunlight.

the shooting timer, as well as to lock the mirror up, when mirror movement might cause camera shake. The shutter dial sets the shutter speed. Interestingly enough, there are no time indicators, such as ¼ second or ⅟₅₀₀ second, on the dial—just two arrows and some hash marks, indicating which way to turn for faster or slower exposures.

A separate mode lever below the shutter dial is used to set the exposure modes. The camera supports fully automatic operations in the program AE mode. There's also a shutter-priority AE, an aperture-priority AE, and manual mode for shooting. Exposure compensation of up to three stops is available in ⅓-stop increments.

The ISO range extends from 100 to 1600, making it possible to come up with acceptable shots, even in low-light situations. The vertical-travel metal focal plane shutter has a maximum range of a very fast ⅟₆₀₀₀ second to 15 seconds when shooting at 100 or 200 ISO, and up to 30 seconds when in the extended shooting mode.

Metering. The SD10 has three different metering modes. There's eight-segment evaluative metering, center-area metering, and center-weighted averaging metering. The evaluative metering divides the screen into eight independently metered segments. The metered information is comprehensively evaluated and combined for an optimum exposure. With the second type of exposure, a 5mm area in the center of the frame is metered. That's along the same lines as spot metering, but just not quite as tight a metered area. Averaging metering gives the heaviest weight to the center area of an exposure, but also gives some weight to the brightness in the rest of the frame.

Focusing. The camera has an autofocus range of 2–18 EV at 100 ISO, and focusing options include a single autofocus mode (AF-S), and continuous autofocusing (AF-C). There's also an autofocus motion-prediction function.

Flash. The flash syncs at $\frac{1}{180}$ second. It has a hot shoe, but there's no built-in flash. That's not a major issue with professionals, but consumers tend to like to have on-camera flash available, if for no other reason than to add some fill light or trip remote slave units.

Features. The camera has some advanced features, including a data-recovery option for deleted images. If an image is erased from a card, it can be unerased, as long as no other photos have been taken and no other operations have been applied to the CF card. That's a unique capability.

For another thing, the camera's recording and playback modes haven't been separated. Images can be captured while playing back other images.

It also has a unique sports-finder viewfinder, which extends the view outside of the actual frame area. A overlay indicates what parts of the image in the viewfinder will be captured digitally and which parts are outside of the frame area. It takes a little while to get used to shooting with it, since you have to remember that not everything in the viewfinder will be in the captured image. Once you're used to it, however, it works very well for predictive framing.

Lenses. While Sigma makes lenses with both Canon and Nikon mounts, the lenses that it makes for its own bodies are not compatible with either system. Sigma SLRs have a proprietary bayonet lens mount. The review unit came with the EX 20–40mm/f2.8 DG aspherical lens. Sigma 35mm lenses will work with the digital SLR models, but there is a 1.7× conversion factor. That means that a standard 50mm lens for one of the Sigma SA bodies would have the equivalent focal length of an 85mm lens when attached to an SD body.

Batteries. The SD10 takes either four standard AA, two 3-volt lithium batteries, or external AC power. Apparently it needs all the power that the batteries can deliver. A number of times, it was only able to take 30 to 40 frames per charge—and that was with freshly charged sets of NiMH AA batteries that registered as fully charged with a battery meter. (Five different sets were tried.) The same batteries were loaded into another digital camera and were able to take 50 to 60 more frames, indicating that the power-level really wasn't all that low. With a set of brand new NiMHs, it was possible to get between 100 and 150 frames. That's acceptable.

SPECIALIZED SENSORS FOR SPACE AND SCIENTIFIC APPLICATIONS

Besides commercial applications, CMOS sensors are also being used in many of the miniature cameras that are part of space missions. For example, some of these small cameras, which can be the size of a quarter or even a dime, are used on the rover vehicles that NASA sent to Mars. To further increase the quality of the images that these tiny CMOS-based cameras can capture, NASA is working on what's called hybrid imaging technology (HIT). Theoretically, HIT merges the best of CCD and CMOS technology, in hopes of coming up with a new technology that's better than either. Once implemented, the resulting technology should have higher resolution, better scalability, and reduced power consumption.

NASA is also working on an altogether different type of sensor. Under contract to the space agency, the Jet Propulsion Laboratory in Pasadena, CA, is developing what's being called an SOI (silicon on insulator) sensor. SOI sensors are extremely thin, just 1 micron, and could be applied to just about any flat surface. Because of their extreme light weight and their low power consumption, they could be used for a wide range of applications. Those sensors should be available commercially by the end of the decade. That could be another revolutionary step in digital imaging.

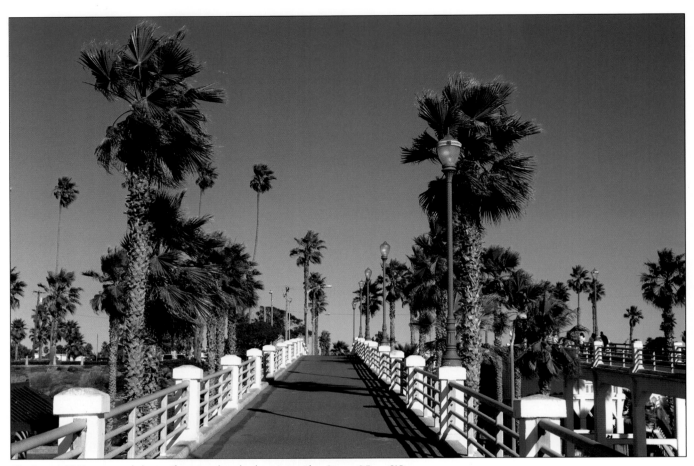

The Sigma SD10 is a good choice if you're already shooting with a Sigma 35mm SLR.

Documentation. Documentation is thorough, well organized, full of diagrams and generally easy to understand.

Removable Media and Connectivity. Captured images are stored on CompactFlash cards, either Type I or Type II, or Microdrives. Images can be transferred directly to either Windows or Mac systems via both FireWire (IEEE 1394) and USB connectivity. Both NTSC and PAL video-out options are also available.

Conclusion. For a serious digital SLR, it's on the slow side. At the highest resolution, it's rated at 1.9 frames per second. That's probably slightly optimistic, but not significantly. In the continuous mode, it was possible to shoot the maximum burst of six frames in four seconds. It then took 51 seconds for those frames to be written to the removable media. That's a relatively long time, particularly in a rapid shooting environment. That means that the SD10 really isn't the right choice for demanding applications, but it's worth considering if you're already shooting with a Sigma 35mm SLR. —R.E.

FINAL THOUGHTS

Digital SLRs are becoming increasingly affordable. With higher resolutions, faster focusing, and more sophisticated exposure controls, they are getting to the point that they're competitive in handling and image quality with film SLRs. However, they are continuing to evolve.

In the early days of 35mm film SLRs, a manufacturer would release a new model, at most, every few years. The pace has quickened considerably with digital SLRs. Some companies are introducing several models per year.

In some cases, the new models are just updated versions of what's already available. Others are totally new designs. Whether you decide to go with one of the models covered in this book or something else, it's important to get as much information as possible before making any purchasing decisions.

RESOURCES

The following is a list of web sites for the manufacturers included in the book. All links are current as of the date of publication.

Adobe Photoshop Software
www.adobe.com

Bibble and MacBibble Software
www.bibblelabs.com

Phase One Capture One Software
www.c1dslr.com

Photo Mechanic software
www.camerabits.com

Canon Digital SLRs
www.canoneos.com

Fuji S2 Pro
www.fujifilm.com

Kodak 14n
www.kodak.com/global/en/professional/features/
featuresIndex.jhtml

Nikon Digital SLRs
www.nikonusa.com

Olympus E-1
www.olympusamerica.com

Pentax *ist D
www.pentaxusa.com

Sigma S10
www.sigmaphoto.com

Silverfast DCPro Software
www.silverfast.com

GLOSSARY

AdobeRGB: A standardized RGB color space containing roughly the gamut of colors that can be reproduced by a high-end commercial CMYK lithographic printing press.

Bayer array: The pattern of red, green, and blue filters that allow the photodiodes in the image sensor, which are only responsive to brightness (luminance), to generate color information. There are as many green filters in the array as there are red and blue combined in order to create a response similar to human vision.

buffer: Volatile memory in the digital SLR that temporarily stores image information before it is written to the removable media.

burst: The ability of a digital SLR to capture images continuously one after another without stopping. The number of images in a burst is a function of many contributing factors, including the size of the camera's buffer memory, the write speed of the removable media, and sometimes the file format.

CCD: Charge-coupled device. A type of image sensor used in digital SLRs. Light energy strikes individual photodiodes making up the image sensor and is converted into an electrical charge. This electrical charge is read from the sensor array sequentially and converted from analog voltage to digital information in computer chips separate from the image sensor itself.

CMOS: Complementary metal oxide semiconductor. A type of image sensor used in digital SLRs. The term "CMOS" actually refers to the type of transistor used to amplify the voltage converted from the photodiode charge resulting from the light energy. The CMOS transistors are an integral part of the image sensor along with the photodiodes, so analog-to-digital conversion is done in the image sensor, and the information is read from the sensor in a block rather than sequentially.

CMYK: Acronym for "Cyan, Magenta, Yellow, Black." The subtractive primary colors that printing presses use to simulate the full range of visible color. Also, the color space representing all of the color values that a commercial printing press can reproduce.

color space: A standardized representation of color. There are a large number of color spaces, including RGB, sRGB, CMYK, L*a*b, CIE, XYZ, and more. Digital SLRs generally offer AdobeRGB and sRGB color spaces. AdobeRGB is a larger color space than sRGB, so it is an appropriate choice if the image will be used for commercial printing or high-end output. sRGB is appropriate for images that will only be displayed on screen, on the Internet, or sent directly to desktop inkjet printers.

CPU lens: A camera lens with a built-in processor that provides to and receives from the camera body information such as aperture setting, focusing distance, focal length, etc.

DCF: Design rule for Camera File system. A standard drawn up for the purpose of simplifying the interchange of image files and related files on digital still cameras and other equipment, while supporting higher resolution images and large-capacity memory media. Color space is always sRGB.

digital single lens reflex (digital SLR): A digital capture camera that provides optical viewing of the subject directly through interchangeable lenses.

effective pixels: The number of pixels actually used to form the image. This number is lower than the total number of image sensors on the imaging chip because a certain number of sensors are covered so that

the camera will know what the dark current is in a sensor that is completely black.

Exif (Exchangeable Image File Format): A standard for storing interchange information in image files. Exif inserts some of image/digicam information data and thumbnail image to JPEG in conformity to JPEG specification. Color space is sRGB.

fill factor: The percentage of the area of the image sensor actually taken up by the photodiode. Since extra electronics are required along with the actual photodiode at each location, the sensor may take up only a small fraction of the actual area of the site, particularly with CMOS-type image sensors.

FireWire (IEEE 1394): An industry standard serial interface within a computer and between a computer and an external device. Maximum transfer rate is 50 megabytes per second.

flash memory module: Non-volatile memory where erasing can only be done in blocks or the entire chip. This is used in digital SLR storage media and in some digital SLR cameras that allow functions to be upgraded by downloading and installing firmware upgrades.

gamut: The range of colors that a particular device can reproduce. Device gamuts are a subset of the standardized color spaces, such as RGB or CMYK, in which they work.

image sensor: The semiconductor device that collects light energy in a digital SLR. They are generally of two types, CCD and CMOS.

interpolation: A technique used to increase the size of a digital image file. Some digital SLRs interpolate (resample) files to create a higher-resolution image than the sensor actually catpures.

ISO equivalence: As defined by the International Organization for Standardization (ISO), ISO speeds were meant to define film sensitivities. To ease photographers' transition from film to digital imaging, camera manufacturers created image sensor sensitivities to mimic film sensitivities with ISO equivalent speeds.

JFET imaging sensor LBCAST: Junction Field Effect Transistor imaging sensor Lateral Buried Charge Accumulator and Sensing Transistor. Nikon's term for their latest image sensor design. JFET (Junction Field Effect Transistors) rather than CMOS transistors are used on the imaging sensor to amplify the voltage signal from the LBCAST photodiode. Analog-to-digital conversion is done on the chip and the digital signal is read from the chip two colors at a time, combining the advantages of CCD- and CMOS-based designs.

JPEG (Joint Photographic Experts Group): The original name of the committee that developed the standardized JPEG compression algorithm.

JPEG compression: A standardized file format that reduces file size of image files by reducing the amount of information in the data. JPEG files must be uncompressed by interpolating the lost information before they can be used.

JPEG-2000 compression: A potential successor to JPEG compression that provides "less lossy" compression and higher-quality images when the files are uncompressed.

LCD (Liquid Crystal Display): The electro-optical device used to display data and image information in digital SLRs.

lens conversion factor: A number used to convert the focal length of a 35mm film camera lens to the effective focal length of the lens when it is used on a digital SLR. The lens conversion factor for the Kodak Pro 14n and Canon EOS 1Ds is 1.0x, as their image sensor is the same size (36mm x 24mm) as a 35mm film frame. Digital SLRs with image sensors smaller than a 35mm film frame will have lens conversion factors ranging from 1.3x to 2.0x.

MBps: Megabytes per second.

megapixel: One million pixels.

microlens: A tiny lens required at each photodiode site in order to focus photons onto the photodiode that would otherwise fall on the surrounding electronics, reducing sensitivity. Not used in Kodak digital SLR sensor designs.

NEF: Nikon Electronic Format. Nikon's name and file extension for its proprietary RAW format.

non-volatile memory: A type of memory used in storage media that retains the information stored when the power is off.

pixel: Picture element. The digital data derived from the image sensor and stored as the smallest resolvable rectangular area of an image. The number of pixels in the final image is determined by the digital pro-

cessing and is only indirectly related to the number of photodiodes in the image sensor.

RAW: The generic name for proprietary image storage formats from digital SLR manufacturers. RAW files contain the unprocessed digital information from the image sensor. Nikon RAW files have the extension ".NEF", Canon's are ".RAW", Kodak's are ".DCS", etc.

removable media: The name for the type of non-volatile storage media supported by the digital SLR. Common types are CompactFlash, SmartMedia, SecureData, MultiMedia Cards, and Microdrives.

resolution: In digital data, the number of horizontal pixels multiplied by the number of vertical pixels. The effective resolution of a digital SLR is the important number. It is the number of effective horizontal pixels multiplied by the number of effective vertical pixels. (See "effective pixels".)

RGB: Acronym for "Red, Green, Blue." The primary colors that digital cameras use to simulate the full range of visible color. Also, the color space representing all of the red, green, and blue values that the eye can distinguish.

sensitivity: The responsiveness of the image sensor to light. Both CCD and CMOS devices have an optimum ISO equivalence of about 100. Amplifying the tiny voltage from the photodiodes creates higher equivalent ISO speeds. This in turn increases the noise present and decreases the signal-to-noise ratio.

shutter lag: The time delay between when you press the shutter release and when the camera makes the capture.

SLR: Single lens reflex. (See "digital single lens reflex.")

sRGB (standard RGB): A standardized RGB color space developed by Hewlett Packard. The default color space for color monitors and the Internet.

TIFF (Tagged Image File Format): An industry standard file format designed for uncompressed image data in 8-bit RGB. Some Nikon digital SLRs also offer a proprietary lossless compressed TIFF format, YCbCr-TIFF.

signal-to-noise ratio: The ratio of useful image information to non-image information. The signal-to-noise ratio of an image is a function of many factors, including the type of image sensor, the ISO-equivalent speed setting, the capture time, and more.

TTL: Through the lens.

USB (Universal Serial Bus): An industry standard serial interface between a computer and an external device. USB 1.1 supports data transfer to a maximum of 1.5 megabytes per second (MBps). Newer USB 2.0 supports data transfer to 60 MBps.

white balance: The process of color correcting the data gathered by the image sensor so that neutral values are reproduced without a color cast. Most digital SLRs provide automatic white balance, during which the sensor looks at the overall color of the scene and guesses at the correct mix of red, green, and blue light present. Since this system is easily fooled, all digital SLRs provide preset white balances for a variety of conditions and most provide the ability to create a custom white balance for a specific set of conditions.

ABOUT THE AUTHORS

■ RON EGGERS

Ron Eggers is a senior editor with NewsWatch Feature Service, covering imaging, technology, travel, and public safety. He is a technical editor for *Professional Photographer* magazine, and a contributing technical editor for *Photo Electronic Imaging*. He writes the "Digital Perspective" column for *Petersen's Photographic* and is responsible for the magazine's quarterly digital imaging section. He also writes photography and computer articles for various other magazines.

■ STAN SHOLIK

Stan Sholik is a professional photographer in Orange County, CA, where he has had his studio for over 30 years. During that time he has developed a national reputation in a wide range of technology-oriented specialties for his clients in the computer, electronics, medical device and food industries. He has also gained a reputation as a writer with articles in *View Camera* magazine, *Photo Electronic Imaging*, *Photo Lab Management*, *Petersen's Photographic* and *Professional Photographer*.

Together, Ron Eggers and Stan Sholik have also authored two additional books: *Macro and Close-up Photography Handbook* and *Photographer's Filter Handbook: A Complete Guide to Selection and Use*, both from Amherst Media.

INDEX

Photo Retouching with Adobe® Photoshop® 2nd Ed.

Gwen Lute

Teaches every phase of the process, from scanning to final output. Learn to restore damaged photos, correct imperfections, create realistic composite images, and correct for dazzling color. $29.95 list, 8½x11, 120p, 100 color images, order no. 1660.

The Art of Bridal Portrait Photography

Marty Seefer

Learn to give every client your best and create timeless images that are sure to become family heirlooms. Seefer takes readers through every step of the bridal shoot, ensuring flawless results. $29.95 list, 8½x11, 128p, 70 color photos, order no. 1730.

Basic Scanning Guide For Photographers and Other Creative Types

Rob Sheppard

An easy-to-read, hands-on workbook offering a practical knowledge of scanning. Includes selecting and setting up your scanner. $17.95 list, 8½x11, 96p, 80 b&w photos, order no. 1702.

Photographer's Filter Handbook

Stan Sholik and Ron Eggers

Take control of your photography with the tips offered in this book! This comprehensive volume teaches readers how to color-balance images, correct contrast problems, create special effects, and more. $29.95 list, 8½x11, 128p, 100 color photos, order no. 1731.

Traditional Photographic Effects with Adobe® Photoshop®, 2nd Ed.

Michelle Perkins and Paul Grant

Use Photoshop to enhance your photos with handcoloring, vignettes, soft focus, and much more. Every technique contains step-by-step instructions for easy learning. $29.95 list, 8½x11, 128p, 150 color images, order no. 1721.

Beginner's Guide to Adobe® Photoshop®, 2nd Ed.

Michelle Perkins

Learn to effectively make your images look their best, create original artwork, or add unique effects to any image. Topics are presented in short, easy-to-digest sections that will boost confidence and ensure outstanding images. $29.95 list, 8½x11, 128p, 300 color images, order no. 1732.

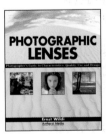

Photographic Lenses

PHOTOGRAPHER'S GUIDE TO CHARAC-TERISTICS, QUALITY, USE AND DESIGN

Ernst Wildi

Gain a complete understanding of the lenses through which all photographs are made—both on film and in digital photography. $29.95 list, 8½x11, 128p, 70 color photos, order no. 1723.

Professional Techniques for Digital Wedding Photography, 2nd Ed.

Jeff Hawkins and Kathleen Hawkins

From selecting equipment, to marketing, to building a digital workflow, this book teaches how to make digital work for you. $29.95 list, 8½x11, 128p, 85 color images, order no. 1735.

Digital Imaging for the Underwater Photographer

Jack and Sue Drafahl

This book will teach readers how to improve their underwater images with digital imaging techniques. This book covers all the bases—from color balancing your monitor, to scanning, to output and storage. $39.95 list, 6x9, 224p, 80 color photos, order no. 1727.

Professional Digital Photography

Dave Montizambert

From monitor calibration, to color balancing, to creating advanced artistic effects, this book provides those skilled in basic digital imaging with the techniques they need to take their photography to the next level. $29.95 list, 8½x11, 128p, 120 color photos, order no. 1739.

Macro & Close-up Photography Handbook
Stan Sholik and Ron Eggers

Learn to get close and capture breathtaking images of small subjects—flowers, stamps, jewelry, insects, etc. Designed with the 35mm shooter in mind, this is a comprehensive manual full of step-by-step techniques. $29.95 list, 8½x11, 120p, 80 b&w and color photos, order no. 1686.

Photo Salvage with Adobe® Photoshop®
Jack and Sue Drafahl

This book teaches you to digitally restore faded images and poor exposures. Also covered are techniques for fixing color balance problems and processing errors, eliminating scratches, and much more. $29.95 list, 8½x11, 128p, 200 color photos, order no. 1751.

The Best of Wedding Photography
Bill Hurter

Learn how the top wedding photographers in the industry transform special moments into lasting romantic treasures with the posing, lighting, album design, and customer service pointers found in this book. $29.95 list, 8½x11, 128p, 150 color photos, order no. 1747.

Success in Portrait Photography
Jeff Smith

Many photographers realize too late that camera skills alone do not ensure success. This book will teach photographers how to run savvy marketing campaigns, attract clients, and provide top-notch customer service. $29.95 list, 8½x11, 128p, 100 color photos, order no. 1748.

Professional Digital Portrait Photography
Jeff Smith

Because the learning curve is so steep, making the transition to digital can be frustrating. Author Jeff Smith shows readers how to shoot, edit, and retouch their images—while avoiding common pitfalls. $29.95 list, 8½x11, 128p, 100 color photos, order no. 1750.

Wedding Photography with Adobe® Photoshop®
Rick Ferro and Deborah Lynn Ferro

Get the skills you need to make your images look their best, add artistic effects, and boost your wedding photography sales with savvy marketing ideas. $29.95 list, 8½x11, 128p, 100 color images, index, order no. 1753.

Web Site Design for Professional Photographers
Paul Rose and Jean Holland-Rose

Learn to design, maintain, and update your own photography web site. Designed for photographers, this book shows you how to create a site that will attract clients and boost your sales. $29.95 list, 8½x11, 128p, 100 color images, index, order no. 1756.

Step-by-Step Digital Photography
Jack and Sue Drafahl

Avoiding the complexity and jargon of most manuals, this book will quickly get you started using your digital camera to create memorable photos. $14.95 list, 9x6, 112p, 185 color photos, index, order no. 1763.

Advanced Digital Camera Techniques
Jack and Sue Drafahl

Maximize the quality and creativity of your digital-camera images with the techniques in this book. Packed with problem-solving tips and ideas for unique images. $29.95 list, 8½x11, 128p, 150 color photos, index, order no. 1758.

The Best of Portrait Photography
Bill Hurter

View outstanding images from top professionals and learn how they create their masterful images. Includes techniques for classic and contemporary portraits. $29.95 list, 8½x11, 128p, 200 color photos, index, order no. 1760.

PHOTOGRAPHER'S GUIDE TO
The Digital Portrait
START TO FINISH WITH ADOBE® PHOTOSHOP®

Al Audleman

Follow through step-by-step procedures to learn the process of digitally retouching a professional portrait. $29.95 list, 8½x11, 128p, 120 color images, index, order no. 1771.

The Master Guide for Wildlife Photographers
Bill Silliker, Jr.

Discover how photographers can employ the techniques used by hunters to call, track, and approach animal subjects. Includes safety tips for wildlife photo shoots. $29.95 list, 8½x11, 128p, 100 color photos, index, order no. 1768.

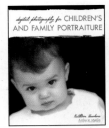

Digital Photography for Children's and Family Portraiture

Kathleen Hawkins

Discover how digital photography can boost your sales, enhance your creativity, and improve your studio's workflow. $29.95 list, 8½x11, 128p, 130 color images, index, order no. 1770.

Professional Strategies and Techniques for Digital Photographers

Bob Coates

Learn how professionals—from portrait artists to commercial specialists—enhance their images with digital techniques. $29.95 list, 8½x11, 128p, 130 color photos, index, order no. 1772.

The Digital Darkroom Guide with Adobe® Photoshop®

Maurice Hamilton

Bring the skills and control of the photographic darkroom to your desktop with this complete manual. $29.95 list, 8½x11, 128p, 140 color images, index, order no. 1775.

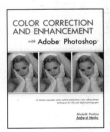

Color Correction and Enhancement with Adobe® Photoshop®

Michelle Perkins

Master precision color correction and artistic color enhancement techniques for scanned and digital photos. $29.95 list, 8½x11, 128p, 300 color images, index, order no. 1776.

Plug-ins for Adobe® Photoshop®

A GUIDE FOR PHOTOGRAPHERS

Jack and Sue Drafahl

Supercharge your creativity and mastery over your photography with Photoshop and the tools outlined in this book. $29.95 list, 8½x11, 128p, 175 color photos, index, order no. 1781.

Beginner's Guide to Adobe® Photoshop® Elements®

Michelle Perkins

Take your photographs to the next level with easy lessons for using this powerful program to improve virtually every aspect of your images—from color balance, to creative effects, and much more. $29.95 list, 8½x11, 128p, 300 color images, index, order no. 1790.

Beginner's Guide to Photographic Lighting

Don Marr

Create high-impact photographs of any subject with Marr's simple techniques. From edgy and dynamic to subdued and natural, this book will show you how to get the myriad effects you're after. $29.95 list, 8½x11, 128p, 100 color photos, index, order no. 1785.

Professional Digital Imaging

FOR WEDDING AND PORTRAIT PHOTOGRAPHERS

Patrick Rice

Build your business and enhance your creativity with the newest technologies, time-honored techniques, and practical strategies for making the digital transition work for you. $29.95 list, 8½x11, 128p, 150 color photos, index, order no. 1777.

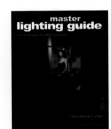

Master Lighting Guide for Portrait Photographers

Christopher Grey

Efficiently light executive and model portraits, high and low key images, and more. Master traditional lighting styles and use creative modi-fications that will maximize your results. $29.95 list, 8½x11, 128p, 300 color photos, index, order no. 1778.